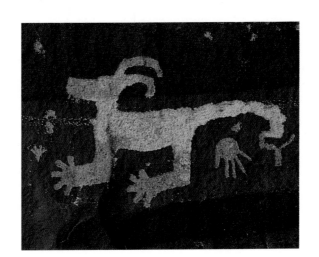

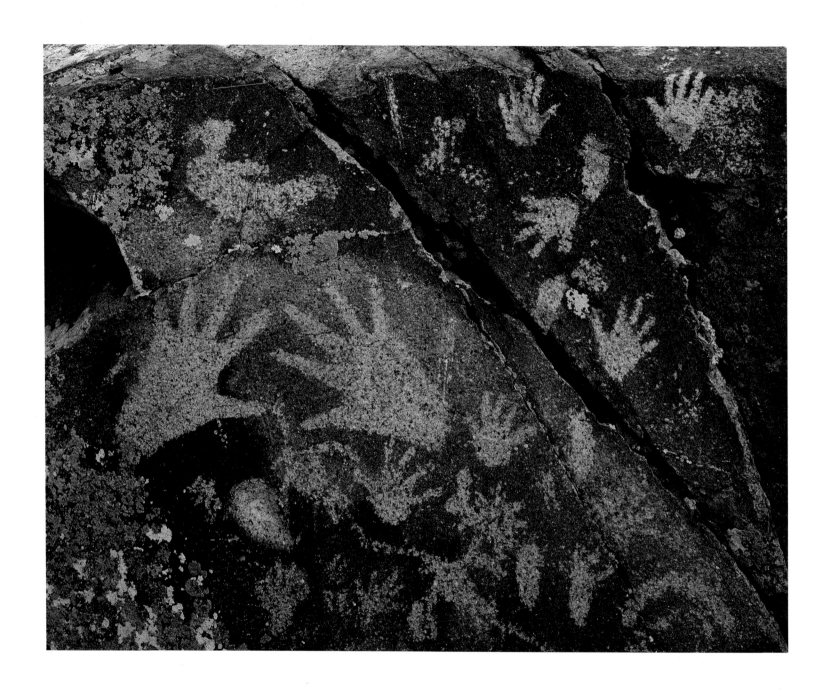

ROCK ART
OF THE
AMERICAN SOUTHWEST

Photography by Fred Hirschmann

Text by Scott Thybony

GRAPHIC ARTS CENTER PUBLISHING™

CONTENTS

International Standard Book Number 1-55868-163-9
Library of Congress catalog number 93-73313
Photographs and captions © MCMXCIV by Fred Hirschmann
Text © MCMXCIV by Scott Thybony
Illustrations © MCMXCIV by Randi McPheron
Published by Graphic Arts Center Publishing Company
P.O. Box 10306 • Portland, Oregon 97210 • 503/226-2402
All rights reserved. No part of this book
may be copied by any means, including artistic renderings,
without permission of the Publisher.
The map has been updated from Campbell Grant's map in
Rock Art of the American Indian, VistaBooks 1992,
and is herewith used with permission.
President • Charles M. Hopkins
Editor-in-Chief • Douglas A. Pfeiffer
Managing Editor • Jean Andrews
Designer • Fred Hirschmann
Production Manager • Richard L. Owsiany
Color Separating • Agency Litho
Typesetting • Harrison Typesetting, Inc.
Printing • Dynagraphics, Inc.
Binding • Lincoln & Allen
Printed in the United States of America

Half-title page: *With features suggesting both a mountain lion and a bighorn sheep, this Anasazi petroglyph in the backcountry of Petrified Forest National Park may represent combined animals.*

Frontispiece: *Rio Grande Style petroglyphs of hands and a parrot decorate volcanic basalt in New Mexico's Tano or Southern Tewa province.*
Endsheets: *Collage, Southwest rock art designs.*

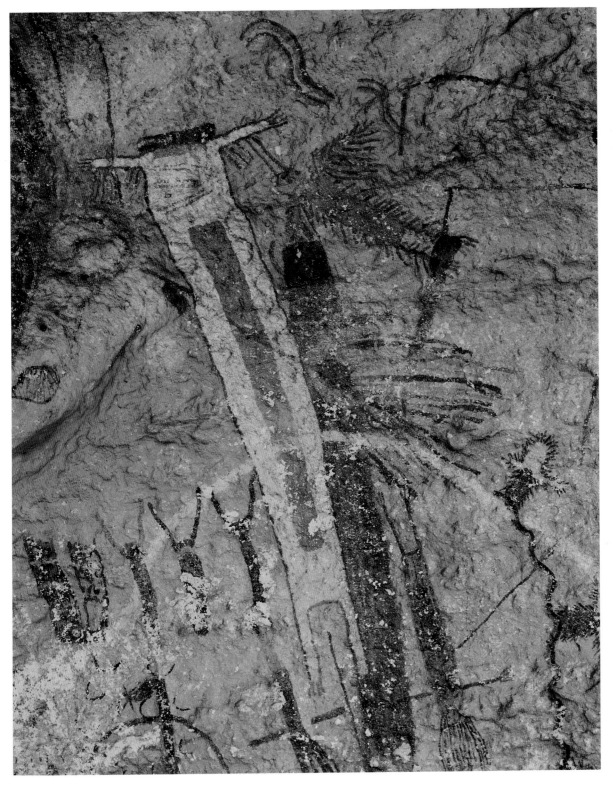

Some of the most impressive rock art galleries in North America occur in the Trans-Pecos region of Texas. More than two hundred pictograph sites are scattered in canyon alcoves and along cliffs above the Rio Grande, Pecos, and Devils rivers. Many panels contain elaborate polychrome paintings. Here, a white shaman-like figure towing a bird-shaped bundle appears to rise from a darker gray anthropomorph.

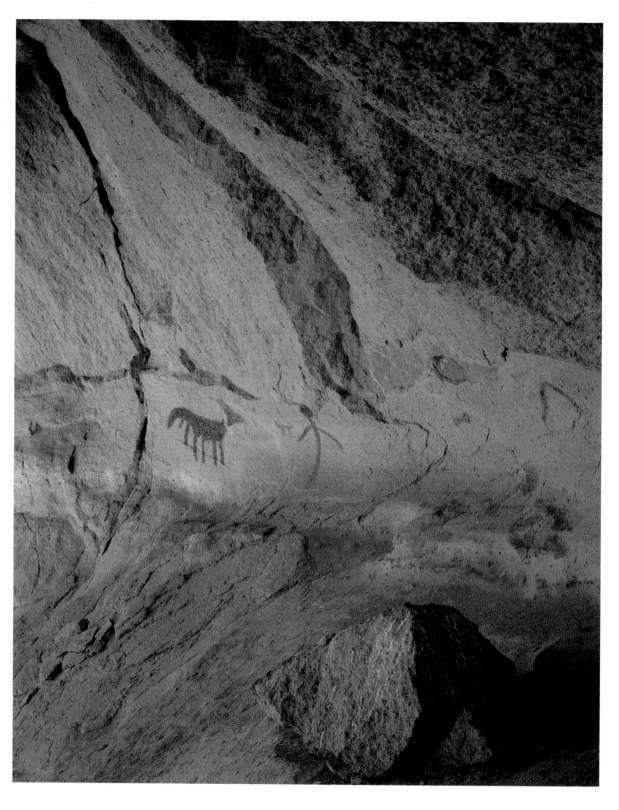

A five-legged coyote and human form peer across the ages from Cueva de las Burras on Big Bend Ranch State Natural Area, Texas. A small chip of pigment naturally spalled off the coyote has been carbon dated at 1875 years before present, plus or minus 75 years, making this an Archaic site.

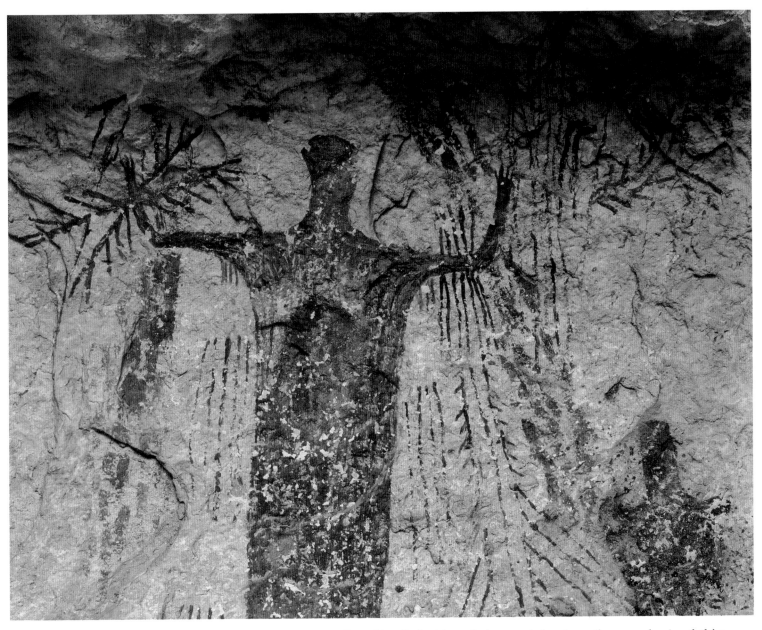

Pecos River Style pictographs incorporate looming anthropomorphs. An atlatl for hunting frequently connects to the figure's right hand, and sticks, staffs, clubs, and other accoutrements adorn both arms. Panther Cave in Seminole Canyon State Historical Park and Amistad National Recreation Area contains exquisite panels.

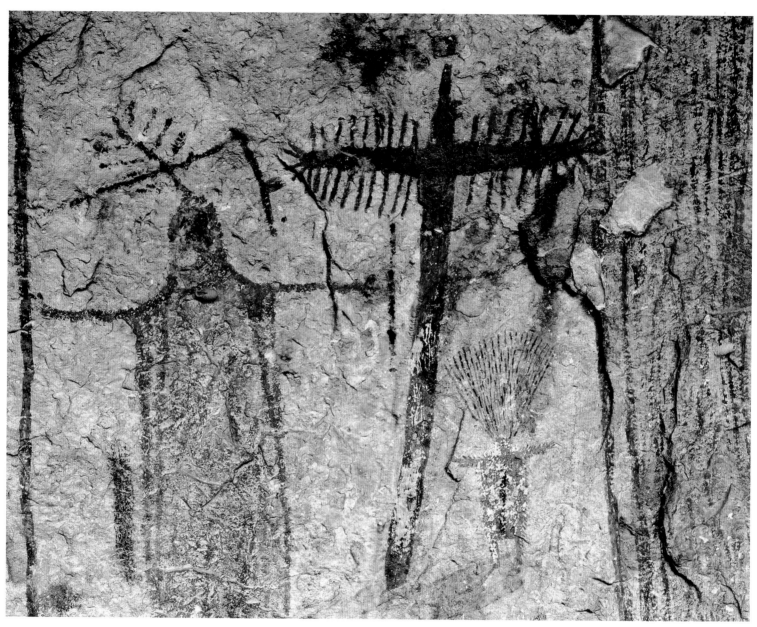

For nine thousand years, people have occupied caves and shelters of the Trans-Pecos region. The Pecos River Style painting may date back four thousand years. Colors were applied with paint brushes made of folded sotol leaves and with molded crayons.

INTRODUCTION

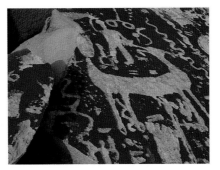

Old Highway 66 lies neglected in the Painted Desert of Arizona, bypassed by the interstate. Where the road skirts an isolated outcrop dotted with petroglyphs, weeds grow from cracks in the pavement. Travelers have left messages on these rocks for hundreds of years. I can read only one. Overlooking an empty road without a soul in sight, it says "Repent."

With prehistoric glyphs, the message is rarely as clear. After early investigators attempted to decipher rock art with discouraging results, most archeologists have avoided making interpretations. They found the field too speculative, too open to explanations that could not be verified.

Instead, they focused their efforts on a descriptive recording of sites and a stylistic analysis of designs. Their studies have led them to recognize variations in form and content among cultural traditions and broad time periods.

The time frame for rock art in the Southwest may extend back eleven thousand years when Paleo-Indians hunted now-extinct animals at the close of the Ice Age. Larry Agenbroad, a Northern Arizona University professor, has found figures of mammoths carved on the cliffs in the same canyon where he excavated their bones.

More than four thousand years ago, during the Archaic period, a dramatic visionary style of rock art appeared among the nomadic bands of the Southwest. The pictographic tradition, surging in different areas at different times, continued within the later pueblo-dwelling cultures. Although it has fallen out of general use, some modern Pueblo Indians still carry on the practice.

Even after a century of academic interest in rock art, the right word to describe the medium has not emerged. I continue to use the phrase, "rock art," without much satisfaction. It does have the advantage of including both pictographs, the figures painted on the rock, and petroglyphs, the forms pecked, incised, or ground into a rock surface. But the term may be misleading.

While graphic images found on rock faces can be appreciated for their beauty alone, aesthetic considerations appear to have been less important than conveying information. No Southwestern Indian culture has a word that matches the western concept of art. Other terms have cropped up in the literature, ranging from iconographs to rock writing, but each has its own limitations.

As the population of the Southwest grows, rock art vandalism increases. Both wanton defacings and well-meaning interest have damaged sites. Smoke stains from New Age rituals and the carving of mock glyphs now mar some rock art panels. Senseless gunfire and the ubiquitous carvings of names and initials destroy more. Occasionally, someone still chalks a petroglyph to make it easier to photograph. Others take rubbings or latex casts, often removing centuries of desert varnish with their impression of the glyph. More often, damage comes from an admirer simply touching a drawing or glyph without realizing hand oils will quicken deterioration and may invalidate new dating methods. For these reasons, the locations of numerous little-known rock art sites need to remain obscure.

The essays included in this work are not meant to be a guide to sites, nor are they intended as an analytical study of rock art. An increasing number of books is available that catalog the various styles and cultural traditions.

One of the first lessons of archeology is the importance of context, the need to study an artifact in its own place. These short essays leave rock art embedded in the personal experience of viewing it. By allowing the sense of wonder to remain, the words fit the mood of Fred Hirschmann's powerful photographs, images that evoke the spirit of a people still with us.

Anasazi petroglyphs in desert varnish, Painted Desert north of Old U.S. 66.

SHAMAN

An old crescent moon floats above the horizon. It rides on the receding tide of night, as sharp prowed as an ancient boat. Far below, the deeper night eddies within the lower reaches of the canyon. Time to get moving. I sit up in the grainy light to put on my boots. Last night, I threw my sleeping bag beneath a juniper, not knowing what I would see when I woke up. The place looks so different this morning, it could be another country.

A cliffrose twists skyward near the rim. In the pale light beyond it, the plateau breaks off into sheer walls, falling to talus slopes that tumble still deeper. The expanse is too vast to take in with a glance. The eye scans the terrain, reading the texture of broken rock and empty space the way the fingertips of the blind move from bump to bump.

I am camped on the rim of a gorge, cut deeply into the Colorado Plateau, with friends Tony Williams and Mary Allen. Both have spent so many years in the canyon country, they become a part of it each time they enter it. Our plan is to look for a rock art site recently discovered by a friend of ours. Photographs showed a panel of superimposed images painted with multiple colors in a style similar to Archaic pictographs thousands of years old. To reach the site, we need to find a way through the upper tier of cliffs.

Several years ago, Mary, who works as a river guide and archeologist, conducted a rock art survey in this canyon. On that trip she spotted a possible route leading through an eroded section of rimrock. If the break goes, we'll be able to get to the site and back in a long day. Tony, a classics scholar turned computer buff, pulls out a couple of climbing ropes from his truck in case we have to force the route.

Once oriented, we find the break Mary marked on her map. Dropping over the rim, we work our way along a shelf and

Archaic Pecos River Style paintings from a Texas tributary of Rio Grande.

down a rock face with good footholds. Below it, Tony pushes ahead to the last line of cliffs and yells back to leave the ropes. He has found a way through, rough but passable.

We side-step down a steep fan of scree and unstable talus, staggering our line of descent to keep from rolling rocks on each other. Soon the slope's angle eases onto a broad terrace a couple of thousand feet below the rim.

Searching for the rock art panel, we separate to check a number of possible locations. Tony follows a ledge and disappears around a shoulder of the rock.

"This is it," he calls out. I find him crouched beneath a low overhang. The rock ceiling hangs a few feet above the sandy floor of a shelter twenty feet deep. Inside the recess, the light takes on a subdued quality, cool and numinous.

We crawl beneath pictographs, scattered across the ceiling, to a back wall covered with overlapping images painted in red and white pigments. The panel is a mix of horned animals, geometrics, plants, and visionary beings. The older paintings, lying underneath, have little claim to the space they occupy. Over time new layers have covered those already in place, burying the deeper past.

A blank mask dominates the scene. Washed with a red tint, it covers a line of horned animals moving at a run. Above it, a row of disks arches between knobs protruding from the mask. Well protected from the elements, the detail remains sharp and the colors true. On the same wall stands a red-antlered elk portrayed in a naturalistic style. The small figure appears lost in the dreamscape of otherworldly images, out of place among the hollow-eyed beings. Stretched thin and armless, they come from an uncertain lineage that could be animal, human, or spirit.

I notice the sharp tang of sagebrush clinging to my boots. The scent penetrates the senses so deeply, it registers far back in my head. A feral smell underlies the sage, perhaps wildcat or mountain lion, brought out by the dampness of the ground.

Quickly checking the pictographs, Tony is puzzled by what is not here. He cannot find the figures he has seen in photographs. Then he notices the floor is smooth and trackless. We have stumbled upon an unknown site.

Tony and I decide to continue looking for the paintings we came to find, but Mary, the rock art specialist, wants to finish recording the newly discovered panel. That is only part of her reason for hanging back. As we take off, she sits alone before the wall of Archaic symbols, just looking.

Outside, bright sunlight glances off the bare red rock. Tony and I cut across the wash, wet by a trickle of runoff, and climb along a ledge on the far side. I notice an old inscription scratched on the cliff face. The name, Altus Jensen, takes some effort to make out, but the date, 1861, is clear. He may have been an early Mormon pioneer.

Mary soon joins us on the bench above where we pick up a trail looping west. Heading a drainage, we spot an overhang tucked below the cap rock, behind a thicket of Gambel oak. It matches the description of the other site.

The three of us duck into the rock shelter and find a ceiling covered with paintings. Most figures have been rendered in red, white, and black pigments; a few have a touch of yellow and olive green. Images crowd together. So many overlap, the eye doesn't know where to start. Packed with detail, the panel has a maplike quality to it. But it's a map without scale, drawn from the perspective of a shaman's flight.

Tony shows me a cat-headed animal, unlike any pictograph we have seen before. About a foot and a half long, it bristles with cartoon whiskers and what may be wings spreading out. Stylized cactus cluster at the foot of the main panel. One, with uplifted arms, appears to be a saguaro, but the nearest saguaro grow in the lower desert a couple of hundred miles to the south. A pale spectral figure stands above them, thin and graceful, with arms open in a simple greeting or prayer.

Partially obscured by superimposed figures, lies another unusual pictograph. Bighorn sheep stretch into thin red lines, curving and interlocking around a core design of other stylized bighorns. The intricate glyph, as finely composed as a sand painting, reflects an unusual symmetry. Thick pigments give another figure a three dimensional, sculpted appearance. White dots, perhaps a cluster of stars, fill a depression higher on the ceiling not far from stick-figure twins, staring down with wide-open red eyes.

Speaking few words to each other, we view these mythical beings in the place they were created. Deep in a remote canyon, hidden beneath the cliffs, the setting has changed little since the imagery first appeared on the sandstone walls.

For over a decade, Mary has recorded this style of pictographic rock art. She has noted a resemblance between these panels and the Archaic rock art along the lower Pecos River in West Texas and along Barrier Creek in southeastern Utah.

Lacking reliable dating methods, estimates for the age of these related rock art styles have ranged widely. The Barrier Canyon Style probably dates back several thousand years but it may be older. This same uncertainty keeps researchers from agreeing on the age of the Pecos River Style. A reasonable estimate places it at four thousand years before the present, but it may turn out to be several thousand years older. Whatever the age, most observers consider both styles to be rooted in a shamanistic tradition reaching deeply into the Archaic.

The Archaic images have their own restless energy. They tap into a force of expression more visionary than later rock art. Hidden away, piled one on top of the other, they may never have been meant for viewing. The act of painting may have been what mattered, a reconnecting with forces greater than themselves. In the act, the vision became real, the spirit visible.

Barrier Canyon Style pictographs from Utah of beings lacking arms and legs.

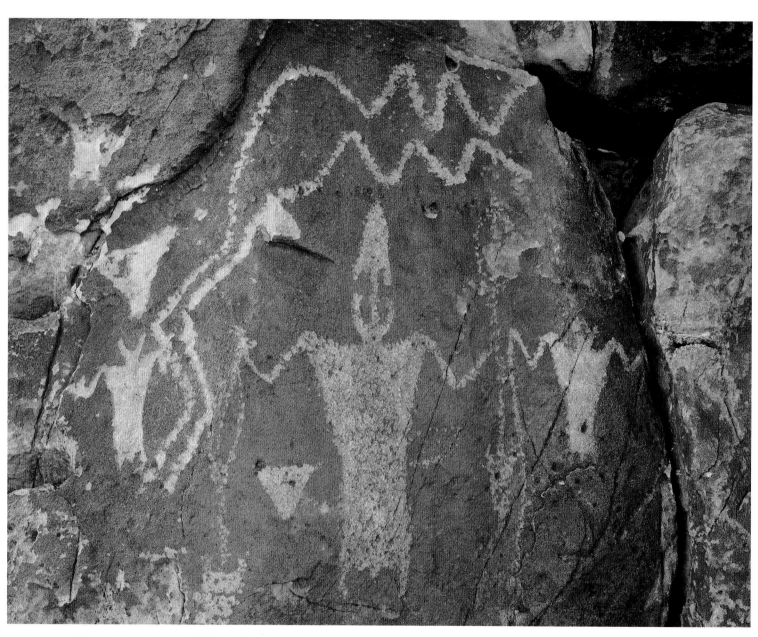

In the Chihuahuan Desert east of El Paso, Texas, Archaic hunters and gatherers carved many broad-shouldered beings in association with spears and projectile points. In some figures, the body or head merges with a spear or atlatl point.

The spear points depicted in these designs closely resemble the shape of Archaic Shumla points originating farther east toward the confluence of the Rio Grande and Pecos rivers. The repetition of points, human figures, and square-shaped animals suggests these panels carved into Cox Formation Sandstone may have represented some form of hunting magic.

Hueco Tanks State Historical Park east of El Paso, Texas, contains a wealth of Jornada Style paintings made by the Desert Mogollon people between A.D. 600 and A.D. 1400. More than three thousand pictographs are hidden within shelters, crevices, and caves. Figures with pairs of large eyes filling trapazoidal heads are thought to represent Tlaloc, a Mesoamerican rain deity.

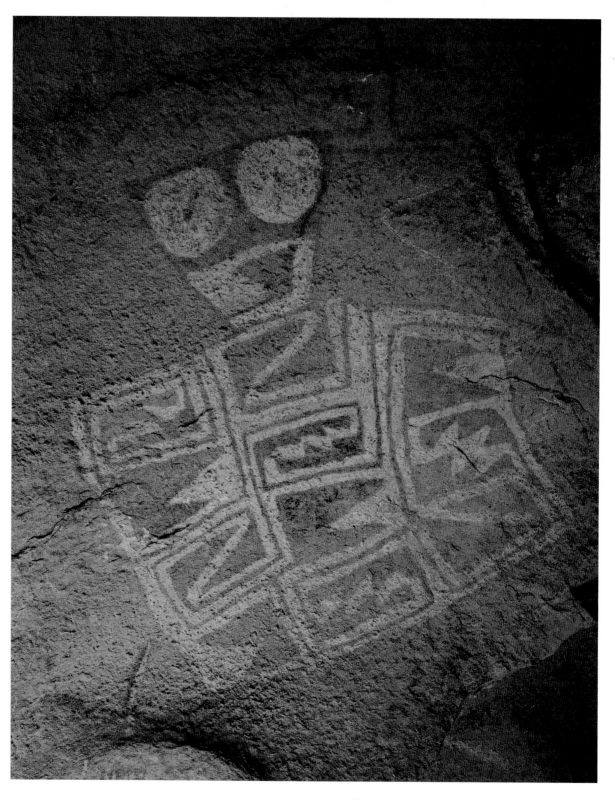

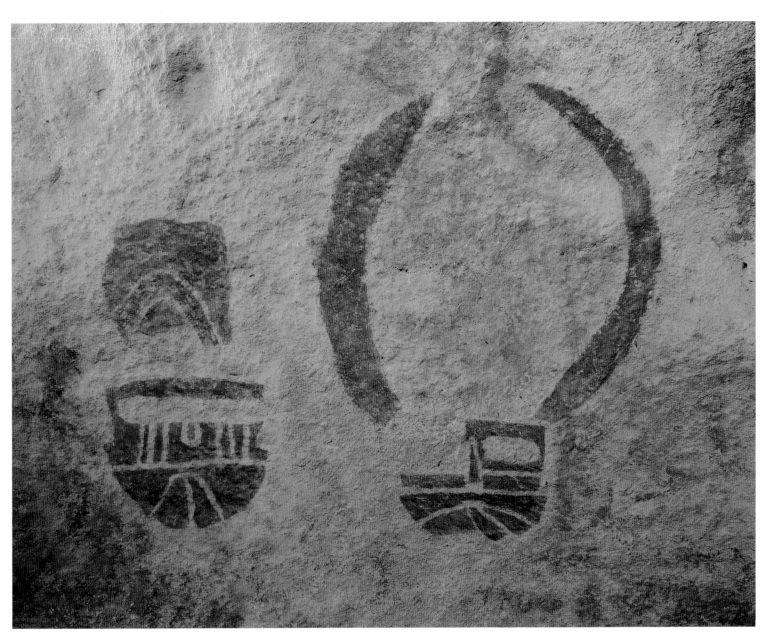

Jornada Mogollon masks with solid painted features tend to occupy hard-to-access, small niches at Hueco Tanks. High on one outcrop, a cave with a belly crawl entrance contains eight masks. Vandals spray-painted this ceremonial grotto in 1992.

Above: *On a desert varnish-streaked wall, a Mogollon painter placed a mask where water would not mar it. Huecos, or water holes, occur among syenite boulders of Hueco Tanks. Water has been a magnet for ten thousand years of human habitation.*

Right: *Open masks tend to occupy easy-to-access cliffs near living areas. Iron oxides provided red pigments while oxides of copper were a source of green. Research at Hueco Tanks showed that about three years after application, paint chemically bonds to the rock.*

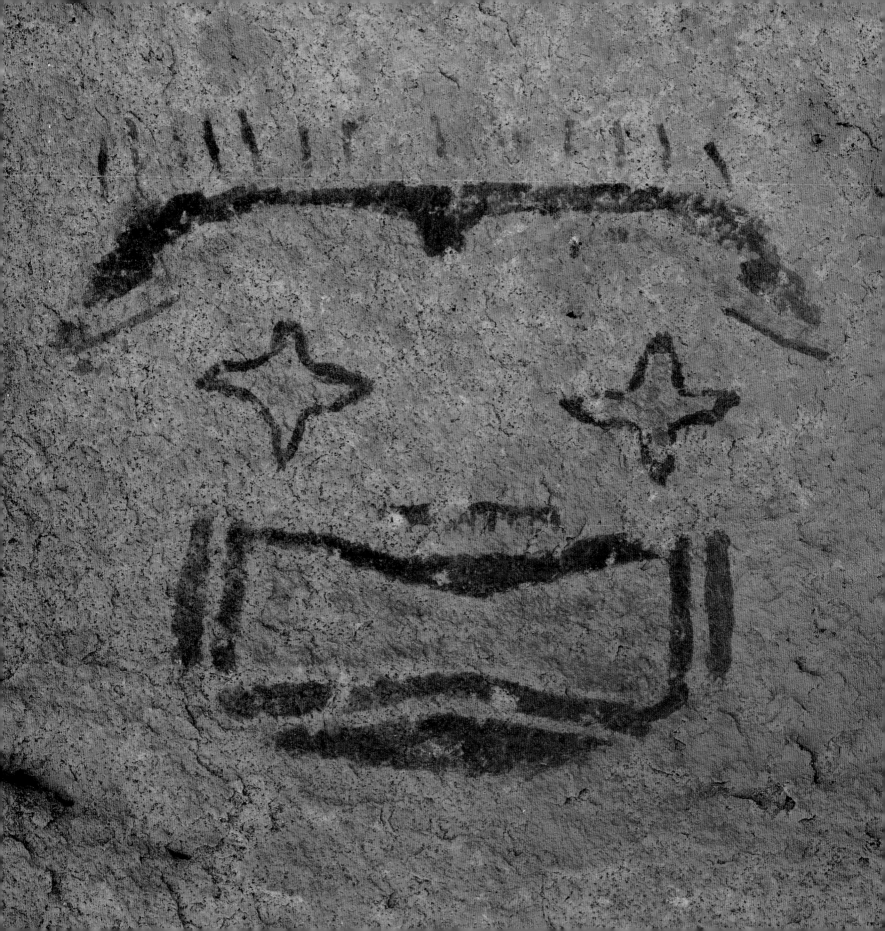

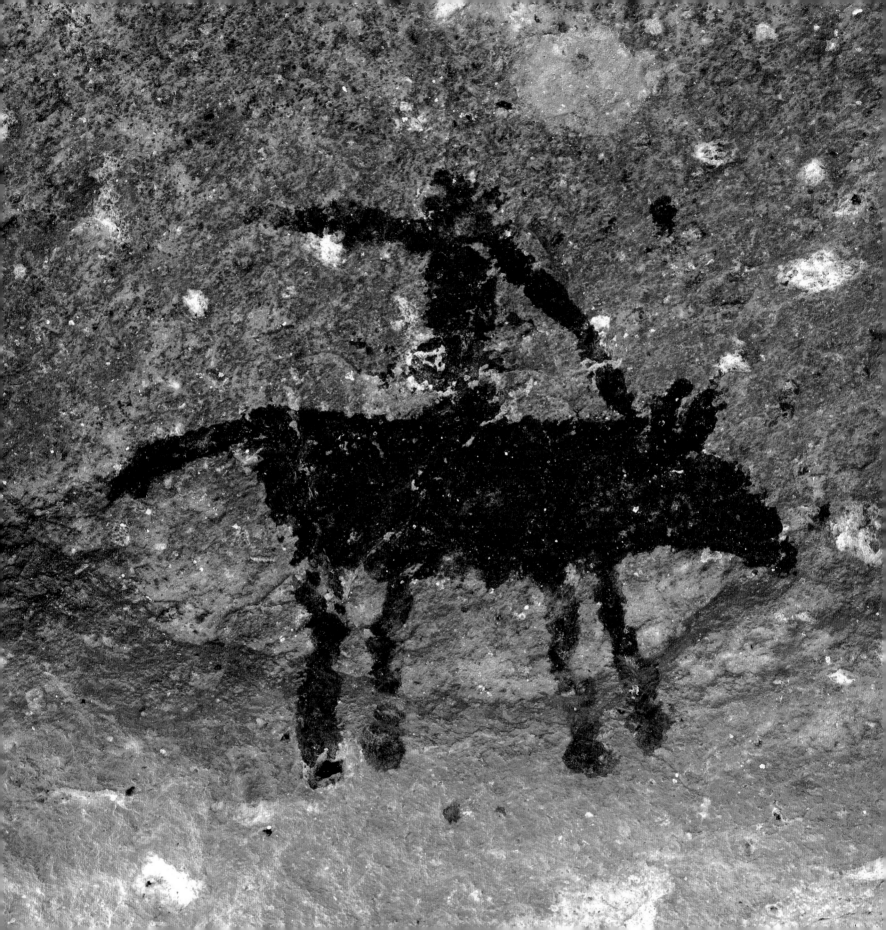

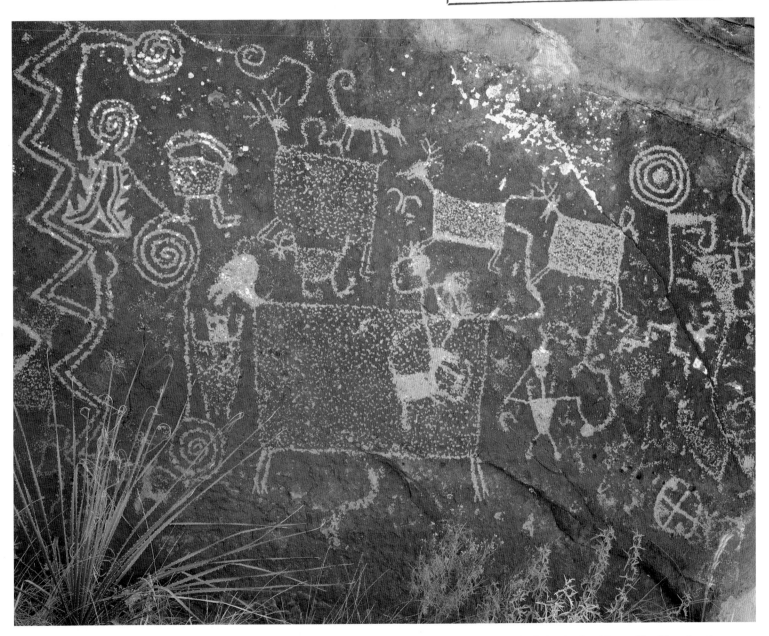

Left: *Rock writing depicting horses with riders signifies a historic site. Spaniards introduced horses to North America during the sixteenth century. This small black painting from Arroyo Segundo on Big Bend Ranch State Natural Area, Texas, is likely Mescalero Apache in origin.*

Above: *Square-bodied animals with considerable animation, geometric designs, and many human forms are but a portion of an elaborate twenty-seven-foot-long petroglyph panel east of El Paso, Texas. One cannot help but feel this site told an important story.*

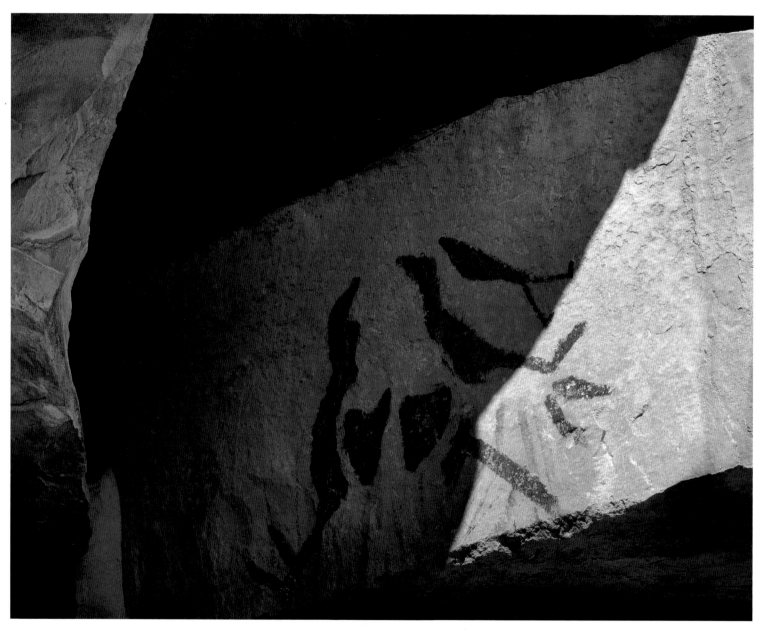

At Paint Rock near the Concho River in Central Texas, a headless figure appears to ascend an afternoon shadow line. A tomahawk and perhaps a split person may speak of eighteenth-century warfare when Comanches were victors over Lipan Apaches.

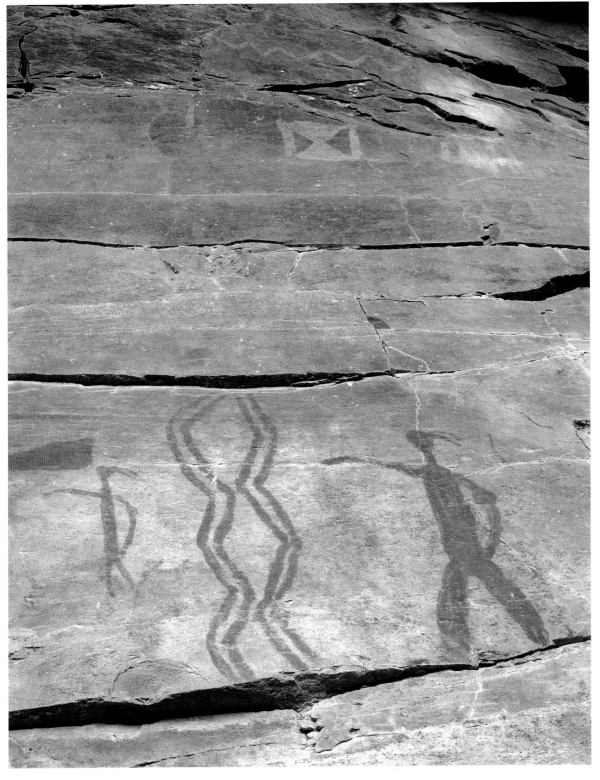

Red and yellow pictographs, possibly Mescalaro Apache in origin, embellish a cliff along Arroyo Manzanillo at Big Bend Ranch State Natural Area. The state of Texas doubled the size of its State Park System when it purchased the 265-thousand-acre Big Bend Ranch in 1988.

The Three Rivers Petroglyph Site in New Mexico contains one of North America's most extensive collections of petroglyphs. People of the Jornada Branch of the Mogollon culture placed an estimated twenty thousand carvings on basalt boulders and outcrops. Three spears pierce this stylized drawing of a desert bighorn sheep.

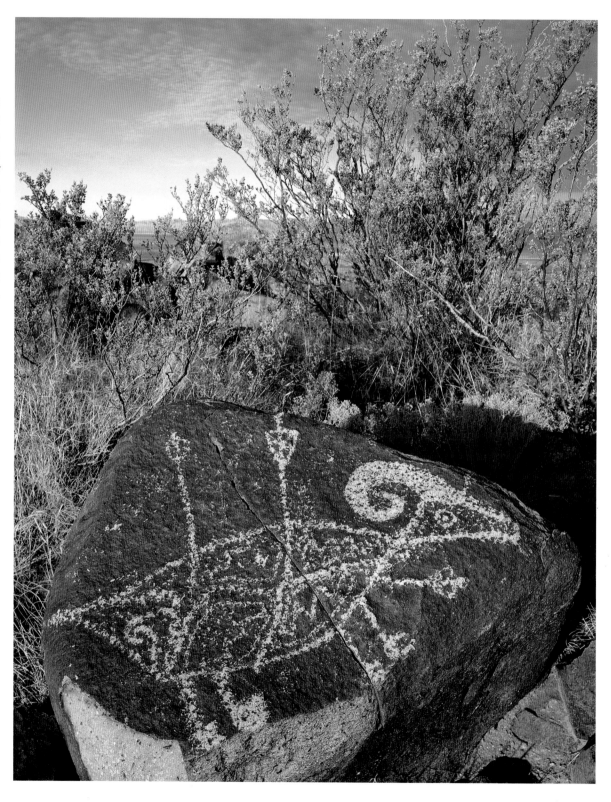

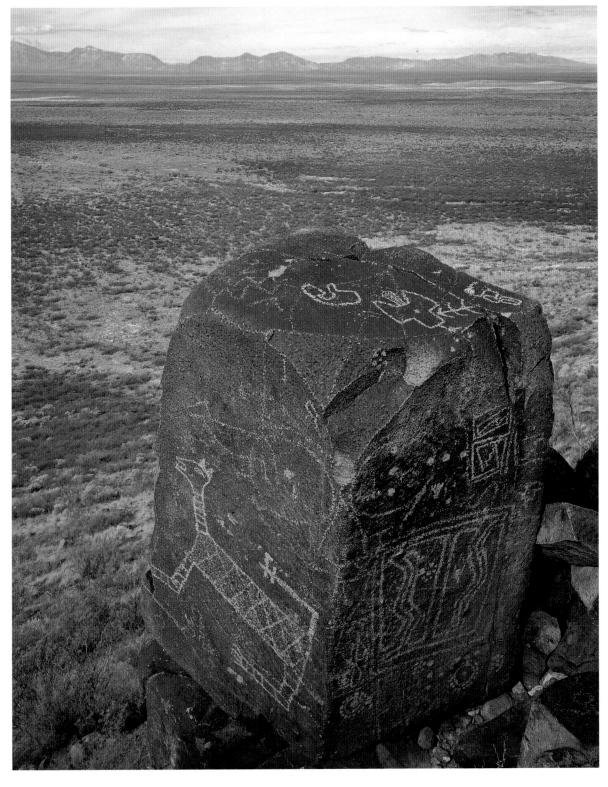

Practically every carving surface at Three Rivers was utilized. Animal decoration like those on this mountain lion draw strong connections to designs occuring on ornate Mimbres pottery. Petroglyphs of wildlife, geometric designs, masks, and sunbursts were made six hundred to eleven hundred years ago and are now protected by the Bureau of Land Management.

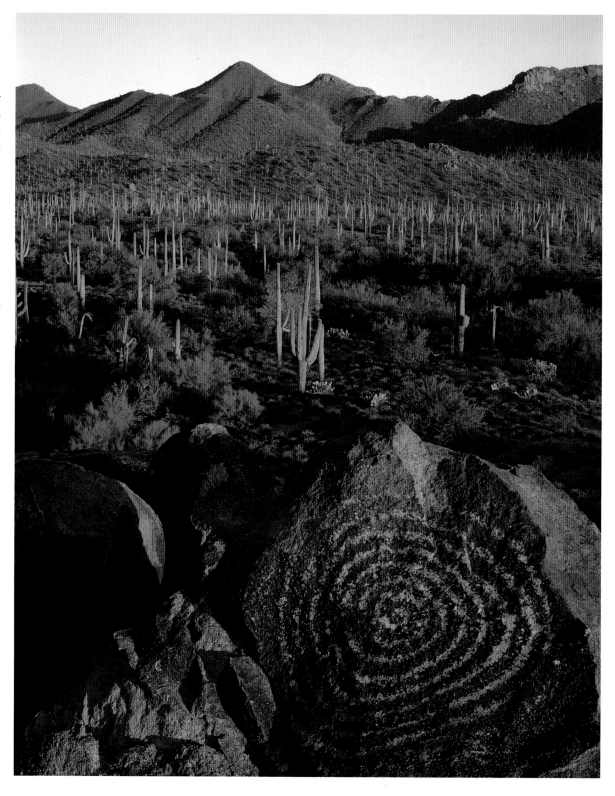

A spiral decorates a boulder atop Signal Hill in Saguaro National Monument, west of Tucson, Arizona. The Hohokam people who carved this petroglyph were expert agriculturalists. Archeologists recognize at least sixteen different species of plants they cultivated, with corn being their most important crop. In the valleys, they built extensive canal systems that irrigated thousands of acres. High country farming was conducted on a smaller scale with check dams holding water in desert drainages.

CIMARRON

Leaving the plains of eastern New Mexico, the road leads into a valley studded with pinyon and juniper trees. Sharp-cut buttes rise above a river called the Cimarron, a Spanish word for "untamed."

Crossing into Oklahoma's panhandle, I enter Kenton, a town with a population of eighteen and only one store. The bumper sticker on a pickup truck parked at the Kenton Mercantile reads "Cattlemen For Christ." Inside the store, a pair of mammoth tusks curve in ten-foot sweeps above a collection of arrowheads and pioneer relics. When I ask about rock art, store owner Junior Heppard tells me to keep my eyes open for a van with Colorado tags. The people driving it have been in the area for several days searching for "Indian writings."

Turning north across the river, I find myself thinking about his choice of words. For the store owner "Indian writings" is a casual phrase, but for rock art specialists it marks a sharp divide. Where some people see only art, others find a system of writing. Between the two lies a wide field of ideas and beliefs. I have listened to a cowboy ramble on about pictographs and space aliens, and to an archeologist dismiss rock art as less useful than a potsherd.

One winter in the Sonoran Desert of Arizona, I worked with archeologists recording an extensive petroglyph site. An outcrop of andesite boulders rose from the desert floor near Deer Valley. Hundreds of rough-pecked figures covered the dark rocks. Our crew spent several weeks recording more than fifteen hundred glyphs, mostly abstract and crudely rendered. We inventoried and photographed, filled in forms and traced the carvings onto mylar overlays, documenting the site with a precision that would have puzzled those who created it.

After analyzing the data, little could be said with assurance: Indians, probably Hohokam, had visited the site over a long period of time; darker glyphs, with a heavier patina of desert varnish, were older than lighter ones. In the end, our crew had little understanding of what this place had meant to those who carved the glyphs.

No attempt was made to decipher the panels. Most archeologists avoid the uncertainties of interpreting rock glyphs. Verification is difficult at best, even when descendants of those who carved the images claim to understand them. Over time, traditions can become ritualized; rituals, rote imitation. Original meanings can shift or be forgotten.

One of the first rock art sites I visited in southern Arizona was at Cochise Stronghold. And the first lesson I learned there was not to call it rock art. LeVan Martineau had invited me to accompany him on a recording trip. Raised by Paiute Indians, Martineau had spent years recording sites and analyzing pictographic panels. Prior to our trip, he had sent a manuscript summarizing his findings to a publisher. But his main concern was to recover for the American Indian a system of writing he believes was lost when the Europeans arrived.

We stood before the stark beauty of a human pictograph painted in red ocher with lines radiating from the top of the head. "This isn't rock art," Martineau said as we faced the panel. "It's a system of writing."

He demonstrated the similarity between the sign language gesture for medicine man and the painting on the wall. Cupping his hand before him in the sign for water, he showed me another example. He often found this water symbol depicted on the rocks as a straight line joined to a semicircle.

Martineau recognizes a link between sign language and pictographic symbols. Ethnographer Garrick Mallery made a similar connection in his classic nineteenth-century study, *Picture-Writing of the American Indians*.

After an extensive search for a method to interpret petroglyphs, Mallery found sign language to be the only useful key.

On Tohono O'odham lands, symbols and a drawing of a woman cover a rock.

25

But he warned against attempts at translation. Only a knowledge of the cultural context of the petroglyphs, he decided, would yield an understanding of the significance of the characters. I watched Martineau record the site without interpreting what it meant. He said he usually avoided translations before carefully studying the photos. But at times he was called upon to make an attempt in the field.

Havasupai Indians once invited Martineau to their village in the Grand Canyon. Tribal elders knew about a rock art panel in the gorge above their village but had only a vague understanding of what it meant. They led the glyph hunter on horseback to the site and asked him to translate it. After studying the markings on the rock, he searched the surrounding cliffs looking puzzled. He told them the panel did not make sense. It described a trail to the rim that began just downstream, but there was no sign of a route. All he could see were sheer cliffs.

The Havasupai looked at each other. Martineau had just described an old trail they called the Rope Trail. A fixed rope, no longer in place, enabled the Indians to scale the first cliff at the point he indicated. He had passed the test.

Years later, I crossed a waterless tract on foot. I found a few figures pecked on a boulder at the mouth of a shallow draw. One symbol looked familiar. Recognizing Martineau's water glyph, I walked up the drainage, curious. I soon came upon thicker brush growing at the foot of a cliff. Kneeling down, I felt the damp ground and noticed a trickle of water. Using a symbol carved on a boulder centuries ago, I had found water.

But I had not found a system of writing. To me, these glyphs appear to be something different, unlike anything found in western societies since language-based alphabets appeared. They are not writing or art as we understand them, but a graphic way to convey information in an unwritten form.

Red pictographs in the Grand Canyon's lower end near Whitmore Canyon.

Some panels contain simple information: trails and water sources, a tally of enemy slain. Some record historical events such as battles and migrations. Others operate on a mythic level, reflecting a world shaped by metaphor and allegory, where a cluster of signs draws the story from the viewer. At their most dramatic, the images become a wordless poetry, joining the texture of rock and the movement of light and shadow with deeper human concerns.

Traveling north of Oklahoma's Cimarron River, I soon spot a van with Colorado tags parked on the side of the road. A man sits by the side door in a Stetson. Slumped next to him is a woman, resting after a long morning of glyphing. "You're looking for Picture Canyon," she says when I ask about rock art. "I can show you exactly where it is."

Last night they camped there, hoping to see the rising sun strike a symbol on the wall of Crack Cave. But they overslept. The glyph enthusiast pulls out an album filled with photos, showing rows of hatch marks cut into the rock. Some appear to be tally marks; a few may be sharpening grooves.

"Ogam," she calls them, referring to an Irish form of writing that came into use during the fourth century. She is certain these panels prove that Old World explorers traveled here centuries before Columbus. She claims a crew of Iberian Celts and Carthaginians crossed the Atlantic and then pushed deep into the North American continent. She changes the subject when I bring up the lack of archeological evidence and the absence of the ogam script in Spain or North Africa.

Until now, her companion has remained silent. Staring into the distance, he points across Carrizo Creek to a break in the cliffs. "Coronado came right through there," he asserts.

In Kenton, the shopkeeper's daughter told me this man often passes through the area asking about certain symbols carved in the rock. "He's very secretive," she said, "and he's not looking for Coronado. He's looking for Spanish treasure."

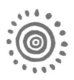

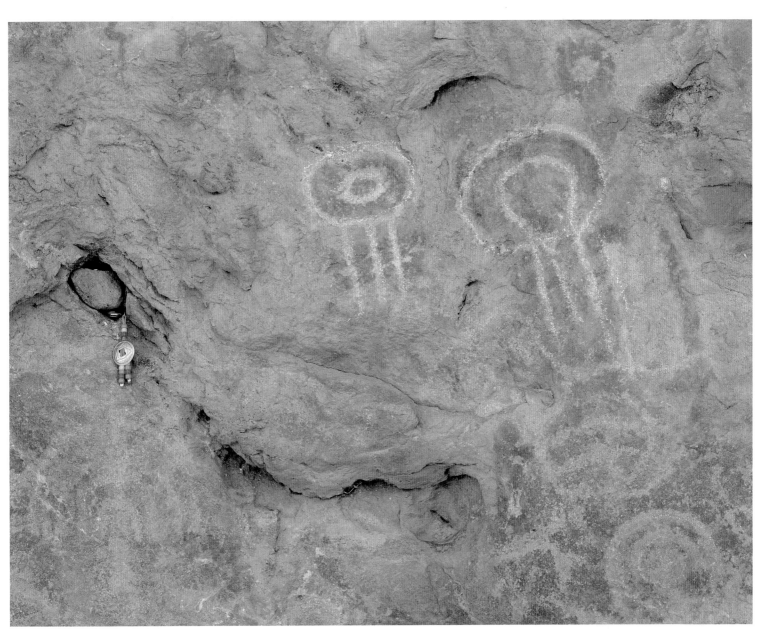

Offerings of coins, jewelry, and other items are placed at a rock drawing shrine on the Tohono O'odham Reservation in Southern Arizona. Likely dating from Hohokam times, this spiritual shrine receives regular visits by Tohono O'odham dwellers of the Sonoran Desert.

Southern Sinagua petroglyphs of a bighorn sheep, horned toad, and spiral grace a cliff in the backcountry of Arizona's Coconino National Forest. The Sinagua culture, which placed an important emphasis on agriculture, arrived in the Verde Valley around A.D. 650.

A pronghorn antelope or perhaps a deer walks across a jointed face of Supai Sandstone on the Coconino National Forest. Rock art often incorporates animal elements. Although nobody can interpret what the original carver was thinking, it seems likely that frequent representations of animals might, in a spiritual way, increase the size of herds or insure a greater likelihood of a kill.

Right: *A Southern Sinagua rock carver created an image of an elk with a bulky body, greatly exaggerated antlers, and an elongated snout. Rather than a push for naturalism, Native artisans often chose to emphasize certain elements of an animal.*

Far right: *Rock art representing the sun is a very common motif found around the world. For agricultural people like the Sinagua, the warming rays of the sun held great importance. Most cultures draw the sun as a circle or a circle with rays.*

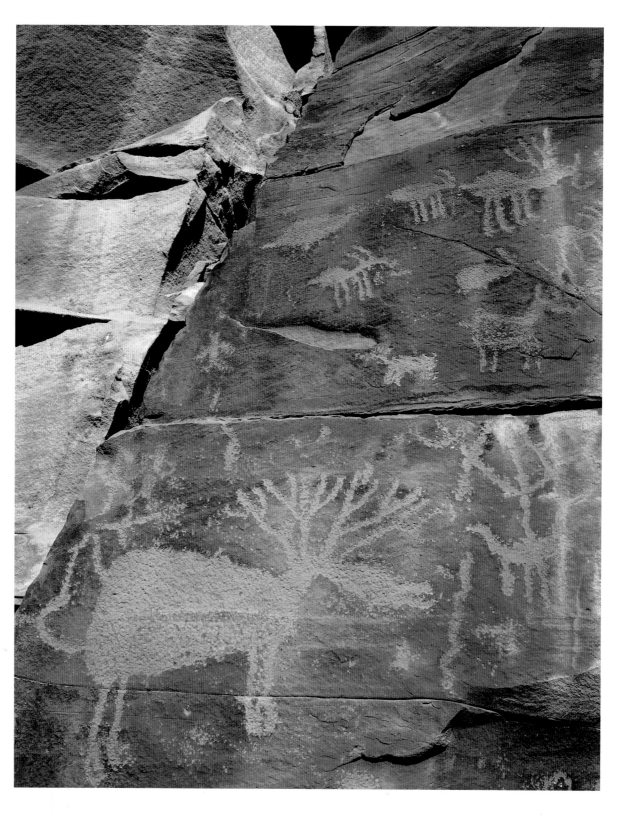

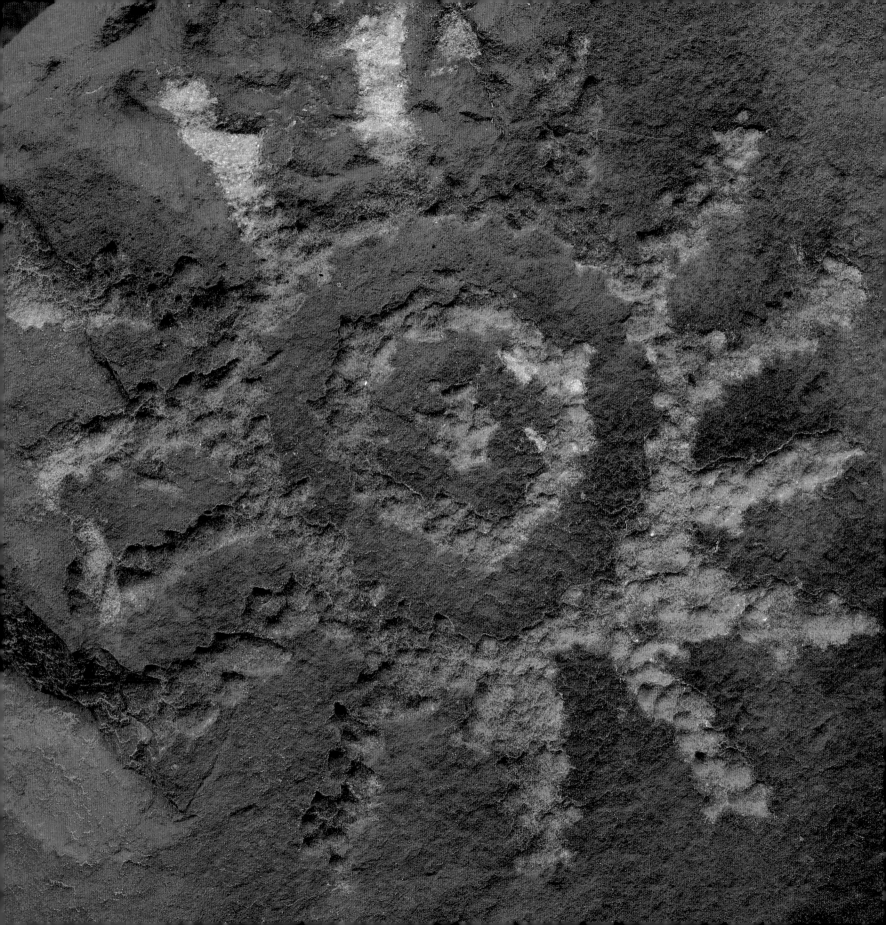

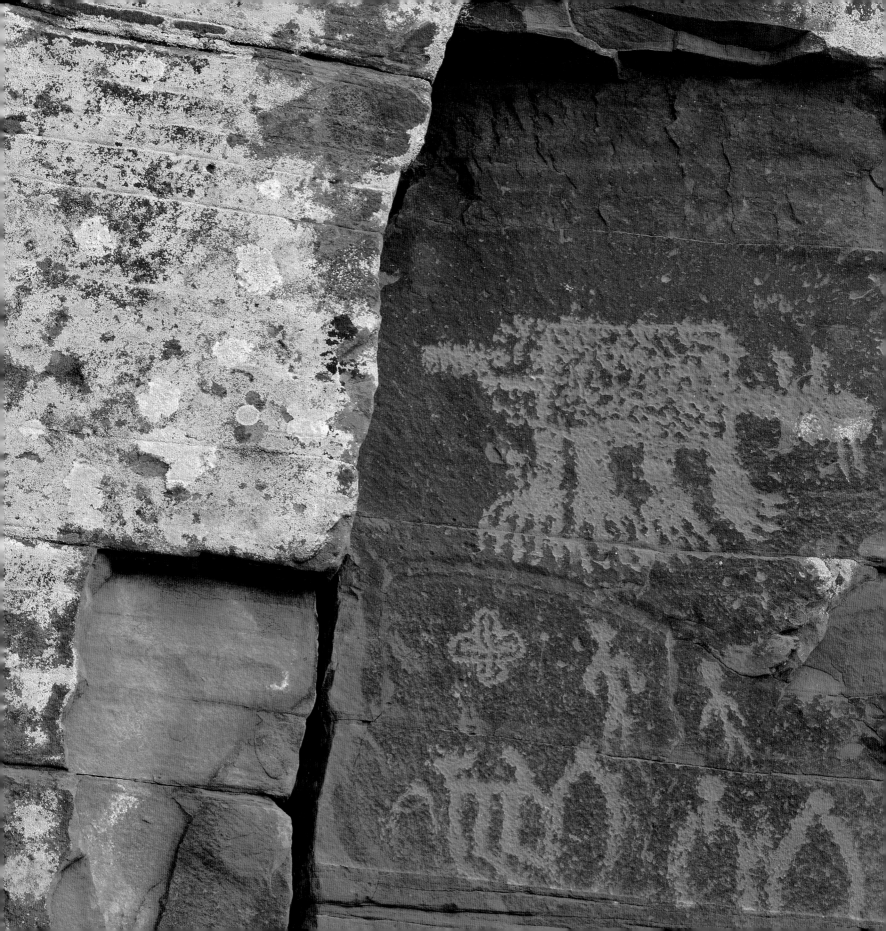

Far left: *Long claws and projecting canines may represent a mythical carnivore or perhaps a bobcat in this panel found in a deep canyon below the Mogollon Rim. The outlined cross frequently appears in Southern Sinagua drawings. In Mesoamerica, this represents the concept of Venus, the morning star. Closer to the actual site, Hopi people say it is the Sand Clan symbol.*

Left: *An exquisite carving of a person walking with a staff and carrying a long load on its head is unique in the Verde Valley. The scene may have been created by someone from a prehistoric pueblo located just up canyon from the site. If so, this would suggest a date of A.D. 1300 to A.D. 1400 when the pueblo was occupied.*

Many interpretations have been offered for the spirals so prevalent in Southwestern rock art. Migrations, journeys to the center, emergence, wind, whirlwinds, water, and solstice markers are some of the more common explanations. Symbols often have multiple meanings that vary by context, culture, and the individual artist. This spiral and quadruped were carved by Southern Sinagua people of Arizona.

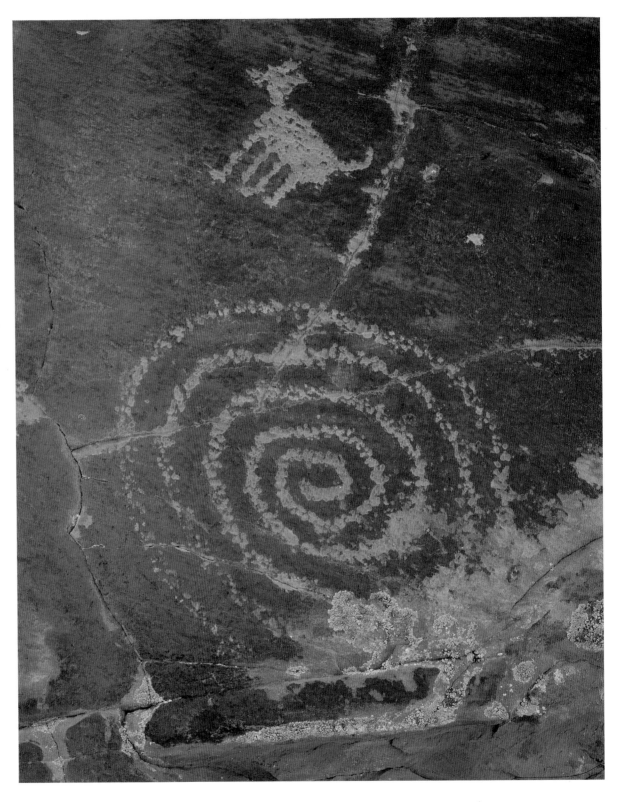

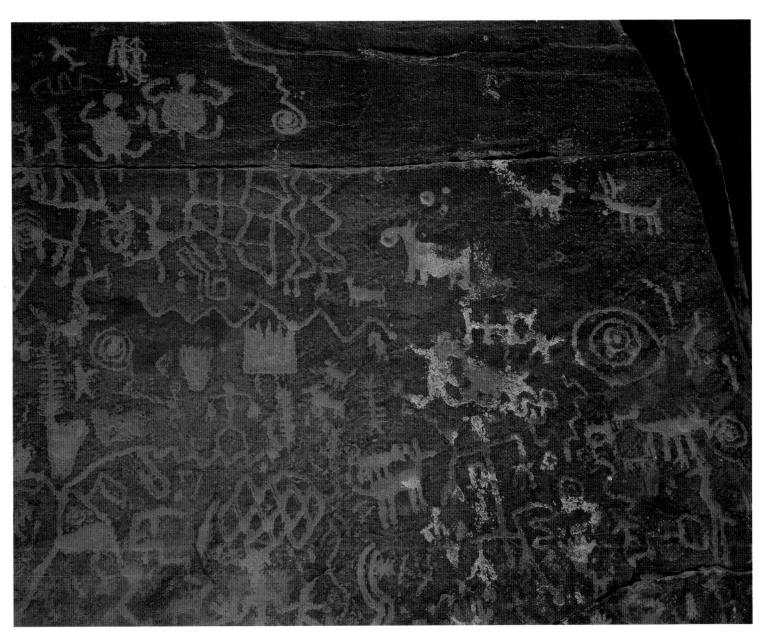

People flourished in Verde Valley from A.D. 700 to A.D. 1400. By A.D. 1425, they had abandoned the area. Had disease killed many, or did most move to other areas? Modern Hopis trace some roots to the Southern Sinagua, who left these carvings.

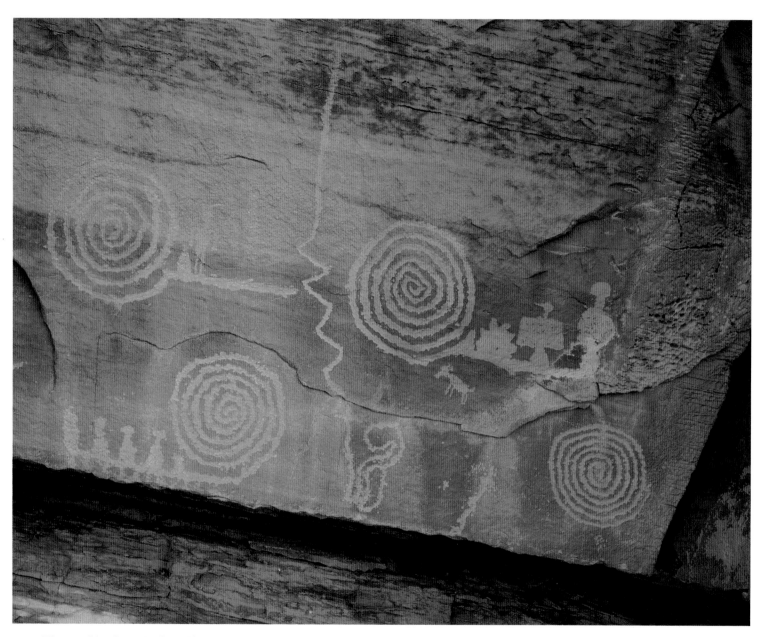

The transition from Northern Sinagua to Kayenta Anasazi culture crossed today's
Wupatki National Monument. These four spirals with associated beings were
likely carved between the time the nearby Sunset Crater erupted—A.D. 1064
to A.D. 1066—and the eventual abandonment of Wupatki around A.D. 1225.

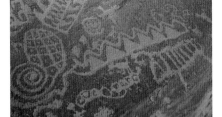

PATHWAY

Drivers stop to scout the Little Colorado River at Black Falls Crossing. The waters run deep and muddy. "It's a left run," says Joelle Clark, river runner turned archeologist. At the wheel of his jeep, Brown Russell, river runner turned lawyer, drops into the current. Like rafts running a rapid, each vehicle threads between rocks and deeper holes to reach the far bank.

"Did you see his upstream ferry angle?" asks Fran Joseph, river runner turned office manager, as Tom Jensen pulls up in the last truck.

Jensen invited me to join the staff of the Grand Canyon Trust on a trip to see some of the country they work to protect. We are returning from Inscription Point on the Navajo side of the river, returning with a sense of loss. The petroglyphs left behind at Inscription Point, remote and seldom visited, have survived for centuries. War parties and traders, missionaries and soldiers have passed these rocks. Now someone, perhaps offended by the figures of copulating animals, has rubbed them out and chiseled over a snake glyph spanning the face of a boulder.

Far to the south, clouds circle the snow-covered San Francisco Peaks. We caravan along a ragged track led by Jim Babbitt, a board member of the Trust with a keen interest in history. Nearing Crack-in-the-Rock Ruins the group veers off to River Camp, a cinderblock line cabin on the Babbitt's CO-Bar Ranch. Even without the heat of summer, it is a bleak locale. "The cowboys call it 'Living Hell Ranch,'" Jim says.

In a thicket closer to the river sits a stone cabin built in the 1880s by the A-1 outfit. "They must have called this place 'Return to Living Hell,'" says Jensen.

Crossing the fenceline into Wupatki National Monument, we reach Crack-in-the-Rock. Due to its isolation and the risk of vandalism, the park service has closed the prehistoric ruin to visitors during most of the year. Park rangers guide parties to the site during one month in the spring and another in the fall. Our group leaves the trucks and walks toward the ruins of the old pueblo, silhouetted against the sky. Broken walls perch on a square-cut butte that rides the tilted strata of the slope like a boat nosing down a wave. A storm front, rolling in from the west scatters clouds far across the Navajo country to the east. Shadows slant down from the clouds like sheets of rain.

Park archeologist Bruce Anderson guides the party along a pathway skirting the cliffs. Rabbitbrush and dry grass shake in the wind around us. As we pass a few excavated rooms, Tony Skrelunas, a Navajo, turns back to wait. He feels uneasy about entering the ruins. The others gather in twos and threes below the rock faces and stare at weather-worn petroglyphs, clustering on the stone like ancient fossils coming to light. Only the hard edges of a culture—the stone walls, the potsherds, the glyphs—remain to hint at a world long gone.

Some human and animal shapes appear emblematic and others anecdotal. But what they meant to the Anasazi remains elusive. In modern Pueblo society, ritual knowledge is closely guarded. The ability to understand a symbol may have been limited to members initiated into a certain ceremonial society.

I once walked through the ruins of a Spanish mission trying to understand the arcane Christian symbols painted on its walls. Without a Catholic priest at my side, I would have been lost. Meaning can drop from symbols like leaves from a tree.

Circling to the far side of the outcrop, we climb above to find a free-standing wall screening the approach to the main room block. Some observers consider it to be a defensive wall. The site is well located to give protection against raiding parties, if needed. But the need may never have arisen. Anderson says that no evidence of warfare has turned up at this pueblo. Other researchers believe that shafts of sunlight, passing through

In Wupatki, a path travels over mountains, likely the San Francisco Peaks.

openings in the wall at different seasons, helped Anasazi sun-watchers keep the ceremonial calendar in sync.

Both archeologists and astronomers have found petroglyph sites throughout the homeland of the Anasazi that interact with light and shadow at key times of the year. On the morning of the spring equinox I once saw blades of light cast onto spiral petroglyphs high on Fajada Butte in Chaco Canyon. Numerous solar markers have turned up at Hovenweep, Petrified Forest, and recently at Crack-in-the-Rock. Rough-pecked glyphs can mask a sophisticated understanding of astronomical events. Seeing a solar marker in action opens a new dimension, making it hard to look at a rock art panel without wondering.

The sun-watcher tradition continues among the modern Pueblo Indians. Traditional priests use the apparent movements of the sun, moon, and stars to mark the seasons and time their ceremonies. But they also accommodate the Gregorian calendar by scheduling the public portions of ceremonies on weekends for those in school or holding jobs.

From the rock island I look across the river's plaited strands. Shards of light lie strewn across the Painted Desert and the stepped cliffs beyond. Rocks glow salsa-red, hot in the cold air.

Beginning in the mid-eleventh century, different groups of people came together at Wupatki to trade. Kayenta Anasazi lived among other Pueblo groups, the Cohonina and Sinagua Indians, who had a strong presence in the area. "They were living together," the park archeologist says. "That's what's so unusual, this cultural mixing that takes place. That's what's unique about Wupatki."

Anderson leads us out the back door of the pueblo. We duck under a low entryway and descend through a tight bedrock crevice, cool and dark. The passageway turns sharply before

An equinox sunlight pointer in Petrified Forest National Park, Arizona.

reaching the foot of the cliff. One summer the archeologist reached for a handhold only to find a rattlesnake sunning itself on the ledge.

We pile into the trucks and jigger up a rocky track that climbs the shoulder of the plateau. On the drive across the desert grasslands, Brown Russell asks each of his passengers how they came to live in Flagstaff. Roger Clark, his wife Joelle, and Brown arrived by circuitous routes from the Southeast.

Certain places such as the Colorado Plateau tend to select those who live there. Remoteness, fewer jobs and lower wages, hard winters and scarce water screen out those not willing to sacrifice a few amenities. Most have continued the nomadic tradition, living here for awhile before leaving, only to return.

"I haven't wandered very much," says Skrelunas who has listened quietly to others tell their far-flung stories. The travels of the Navajo people tell his story. He says his Bitter Water Clan traces its origin to the prehistoric Sinagua Indians. This comes as a surprise since the Sinagua were a Pueblo people generally thought to be ancestors of certain Hopi clans. The boundaries between people are never as clear as we draw them. Volcanic eruptions, Tony says, drove them from the high country near Flagstaff to the Mount Hesperus region of Colorado. Eventually they worked their way south to Big Mountain.

The story of this country is a story of migrations and the end of migrations, of people in search of a place. Spanish, Mormon, Navajo, and Pueblo have all come looking. The figure of a man at Inscription Point holds a staff as he enters an intricate maze. Images pecked on the face of Crack-in-the-Rock show people carrying bundles, filing past with a dog at their heels. Another panel shows people walking a path that turns upon itself into a tight spiral, closing on the Center Place, the end of wandering.

We head across North Mesa aiming for the highway still miles away. Before us, dirt roads branch and branch again, winding among clumps of yellow grass to places only guessed.

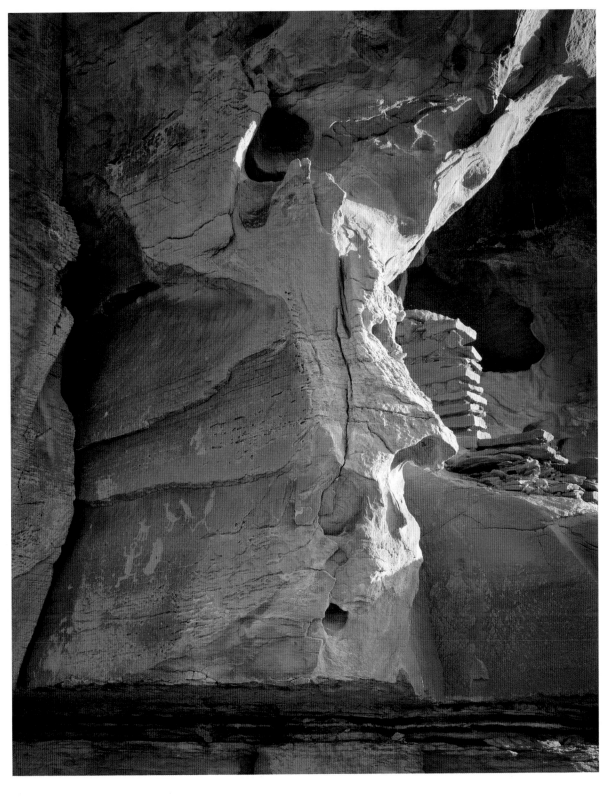

Rock art often occurs in the vicinity of prehistoric dwellings such as this small pueblo in Wupatki National Monument's backcountry. At the zenith of Anasazi culture, a greater population inhabited the Four Corners region of the Southwest than is present today. Archeological sites abound across this arid country.

At Wupatki National Monument, a flute player is etched in sandstone. The body was precisely dinted with a hammer stone and rock chisel while the narrow arms, legs, flute, and zigzag line eminating from the head were finely abraded with a sharp rock.

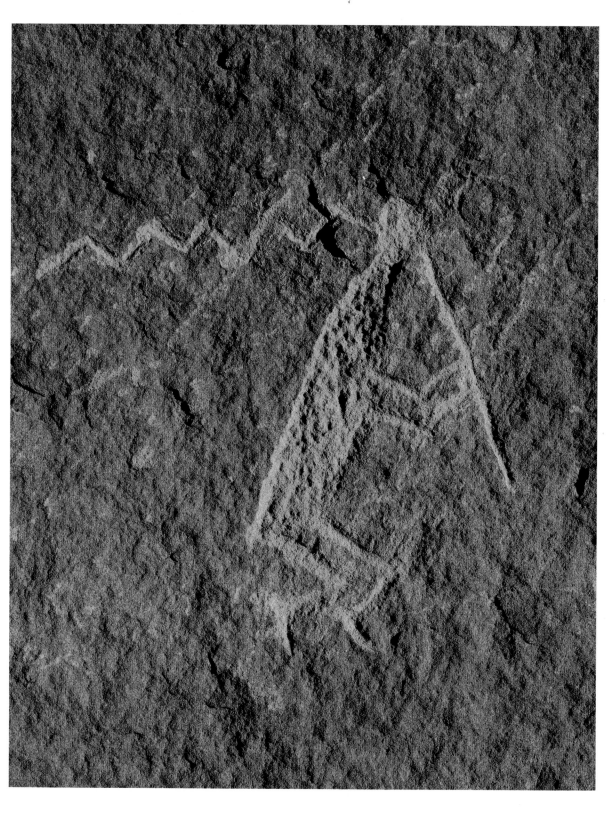

FLUTE PLAYER

Tribal judge Delfred Leslie and I cross a neck of rock leading into the Hopi pueblo of Walpi. Flat-roofed houses pile up in terraced steps where the spur widens at the tip of First Mesa. We follow an unpaved street as gray as the stone houses flanking it. At the head of the Flute Clan Trail, Judge Leslie stops. A pathway leads sharply down the cliff to the desert below. He says the trail is used once every two years when a ceremonial procession climbs to the mesa top with their flutes playing. The ritual recreates the Flute Clan's arrival at First Mesa, ending its long migration.

The judge looks north to a small juniper growing at the foot of the cliff. "That's where they buried the hearts of the Utes," he says.

Tano Indians from the Rio Grande arrived at the Hopi mesas in the late 1600s. Anxious to escape Spanish domination, they accepted a Hopi request for aid in defending the villages against nomadic raiders. They ambushed a Ute war party on its way to attack the Hopi villages. Fighting with arrows and war clubs, the Tano killed all but three of the Utes. The survivors were allowed to carry word of the defeat back to their people. The Tano returned to the village, burying the hearts taken from the four bravest enemy warriors.

Earlier on our drive up the mesa, we passed a petroglyph panel carved into the cliff next to the road. A circle divided into quadrants represented a Hopi war shield, Delfred said. It held the symbol for war, two points meeting tip to tip, along with the sign for peace, two interlocked semicircles resembling joined hands. These represented the alliance among the villages. Next to it, a long line of tally marks indicated the number of enemy slain in various battles.

Judge Leslie and I continue through the old village, passing the Flute Clan house, stacked several stories above the mesa top. Walking past a kiva, Delfred points out a timber used to frame the smokehole. It came from a Spanish mission, he says, destroyed when Pueblo Indians revolted against Spanish rule in the late 1600s.

On my last visit, I talked with Delfred's father, Ebin Leslie, head priest of the Blue Flute Clan and *kikmongwi,* the Hopi name for the village chief. The Hopi elder sat facing the sun on the porch of his home below the mesa. His face showed the stern set of a leader's bearing. He wore his graying hair tied in a knot and a heavy silver ring depicting a man bent over, playing a flute. I made the mistake of calling it a *Kokopelli.* The figure on the ring is not Kokopelli but a flute player, *Lahlanhoya,* Delfred said as he translated his father's words. Though often confused, they are not the same entity. Kokopelli is the deity of the First Mesa Asa/Mustard Clan, I learned, which is not related to the Flute Clan. The old man kachina, called Kokopelli, sometimes shuffles into a village plaza during a dance. He entertains the crowd by chasing the girls, trying to catch one with the crook of his cane. Kokopelli, the judge said, is never depicted with a flute.

Delfred said the flute player, Lahlanhoya, is a clan symbol. On their migrations, the Flute Clan left the emblem carved and painted on cliffs and village walls throughout the Southwest. Every detail of the flute player has meaning, and surrounding figures can be important. Horned animals are often found with the flute player. Bighorns are trailblazers, always taking the lead. They scout the way ahead and find water. They were the ones to locate the trail the Flute Clan took to reach First Mesa.

Hopi Indians, like Delfred and his father, recognize a spiritual connection with the land. Each year, Hopi elders undertake a pilgrimage. They return to shrines marking key stops on their clan migrations, shrines often associated with rock art.

"Our religion, our prayers," the judge says, "that's the way we've held onto the past. Ruins and the symbols on the rock, these are our claim to the land."

A phallic flute player dances on a rock at Petroglyph National Monument.

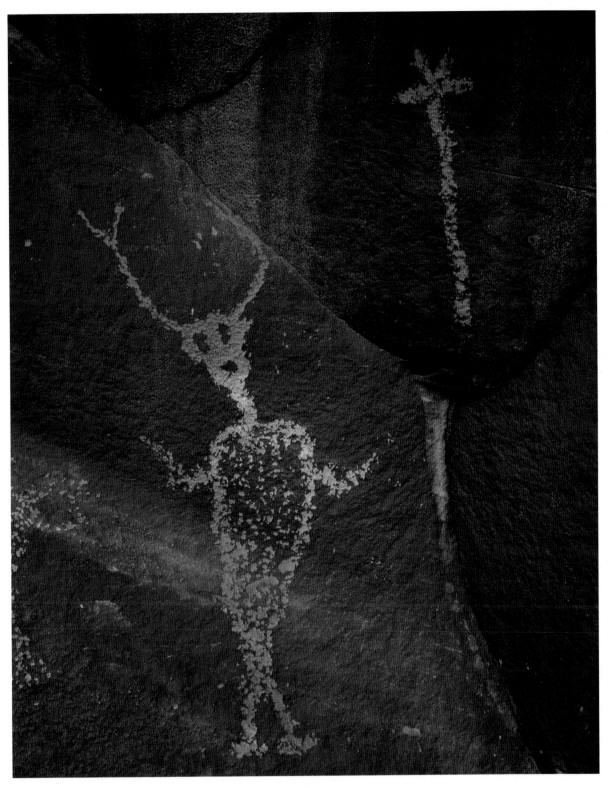

Far left: *Flute players in ancient Anasazi depiction and historic Pueblo drawings come in many shapes and positions. Anthropologists and writers often attribute all as being personifications of Kokopelli; however, modern Hopis disagree. The Kokopelli kachina never plays the flute. Members of the Hopi Flute Clan say flute players carved and painted on rocks across the Southwest trace their migrations. This example comes from Petrified Forest National Park.*

Left: *An antlered human from early Anasazi Basketmaker times stares from a rock face along a tributary of the Little Colorado River in Northern Arizona. Ideal sites for petroglyphs are light-colored rocks with a dark coating of desert varnish. Bacteria on a rock's surface oxidizes manganese and iron from wind-blown dust. With the help of rainwater, the living bacteria fix manganese oxide, iron oxide, and clay to the rock surface.*

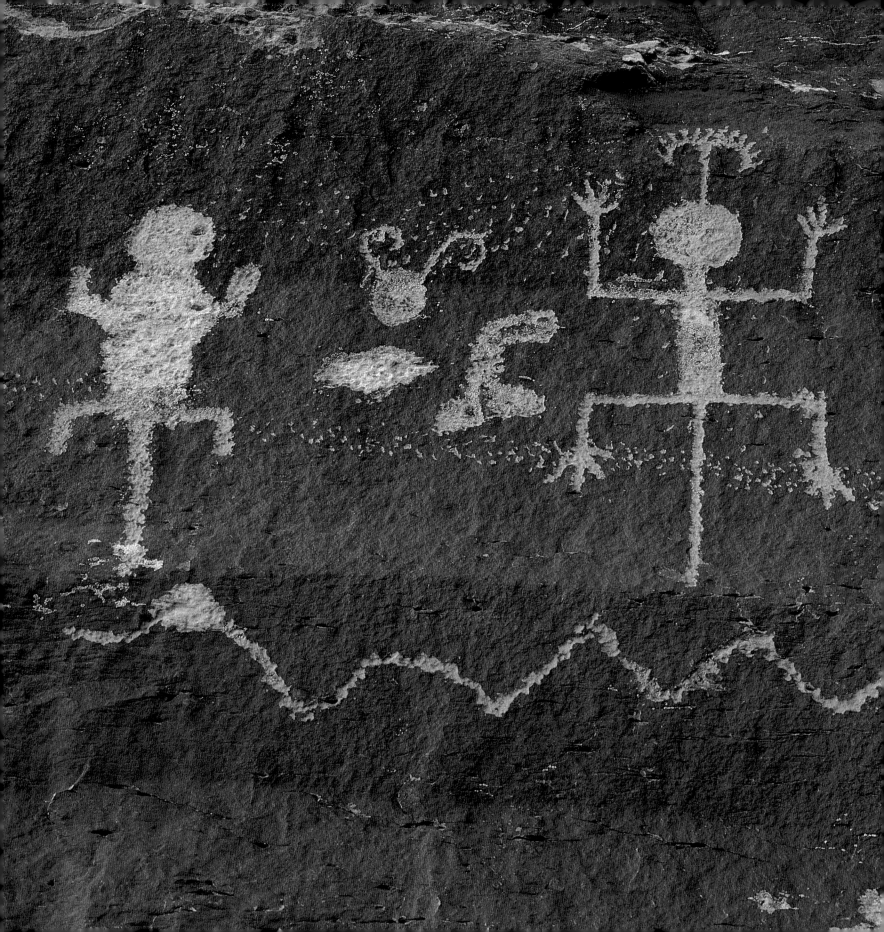

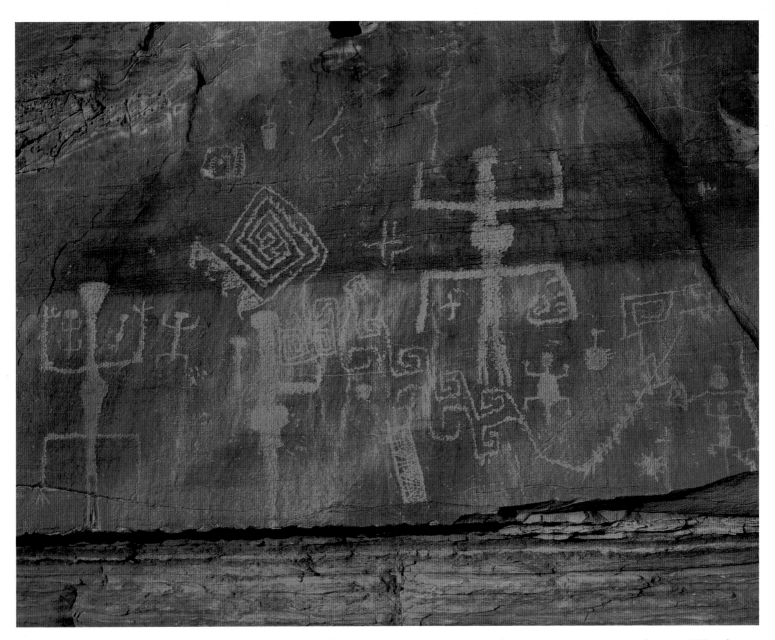

Left: *A steel blue patina takes thousands of years to form. The Anasazi petroglyphs from Petrified Forest National Park are at least eight hundred years old, but exhibit virtually no repatination. Figures that merge from lizards to humans are a common design in Anasazi petroglyphs.*

Above: *Lizards appear in Anasazi rock art after A.D. 1000 and are often depicted "pregnant," as in this group from Wupatki National Monument. The Zunis tell of a time in the beginning when people still had tails and looked a lot like "lizard men."*

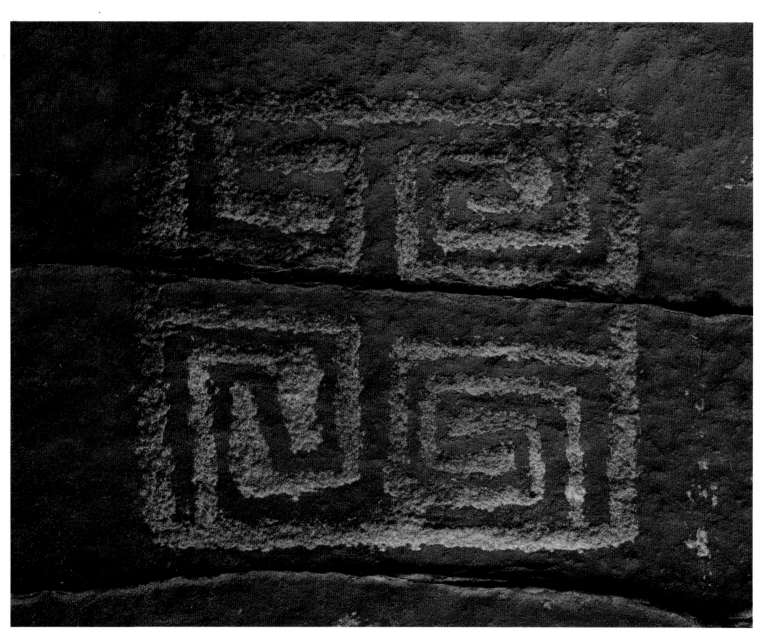

In the region of the upper Little Colorado River, rectilinear
patterns are represented in Anasazi rock art as well as on
textiles and ceramics. Such geometric designs can occur in
limitless patterns that could be conceived as continuing forever.

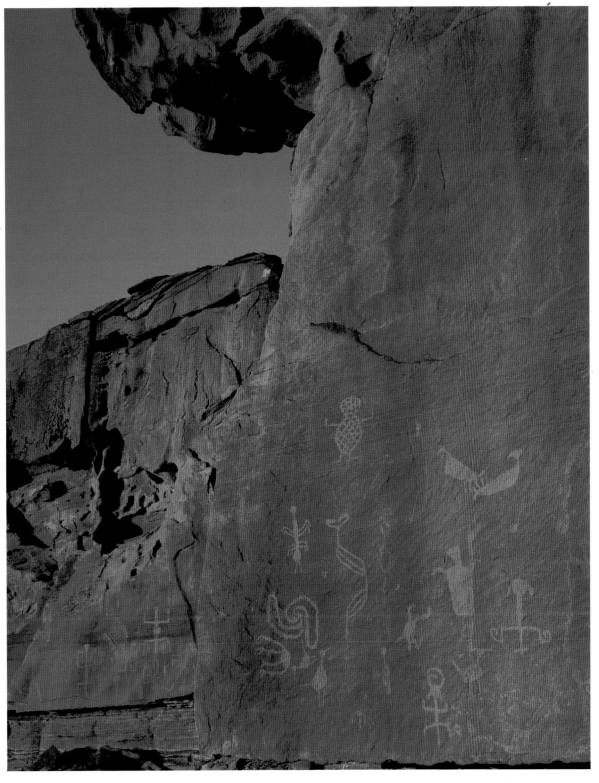

Kayenta Anasazi petroglyphs of lizard woman, copulating birds, an insect, and assorted other figures face the rising sun in the backcountry of Wupatki National Monument. Following the eruption of nearby Sunset Crater, Sinagua and Anasazi farmers found the volcanic ash provided rich nutrients and helped retain moisture for their crops.

Use of bows and arrows by the Anasazi replaced the atlatl after A.D. 500. Shot arrows were more lethal than thrown atlatl points. Although the Anasazi were successful farmers of corn, squash, and beans, hunting wild game supplimented their diets.

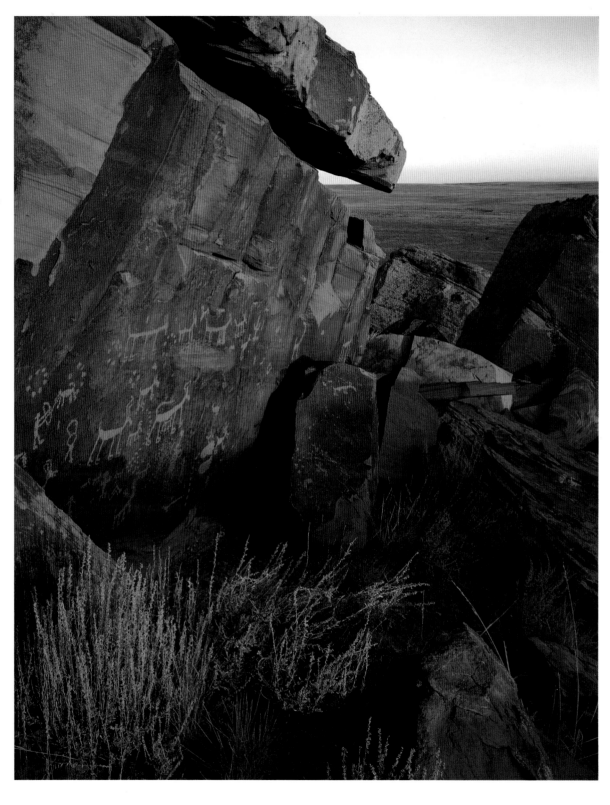

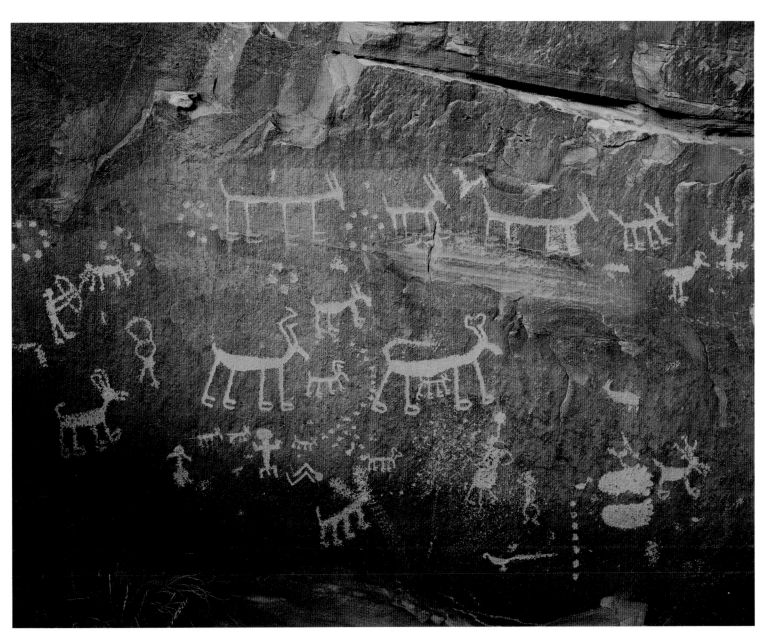

Details of the panel at left reveal pronghorn antelope with young, a parrot or macaw, and even a saguaro cactus. These petroglyphs occur east of Holbrook, Arizona. The closest saguaros grow 125 miles to the south, and wild parrots occur in Mexico.

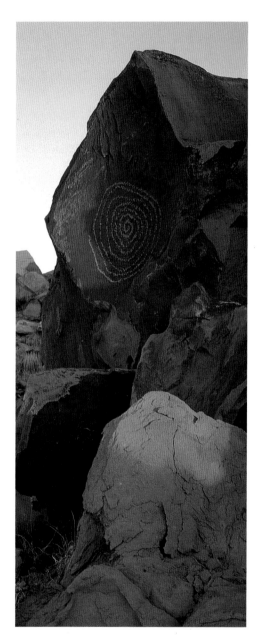

At sunrise on the summer solstice, a shadow line slides across a spiral and becomes a straight line when it bisects the spiral's center. Petrified Forest National Park contains numerous Anasazi designs that interact with sunlight during summer and winter solstices.

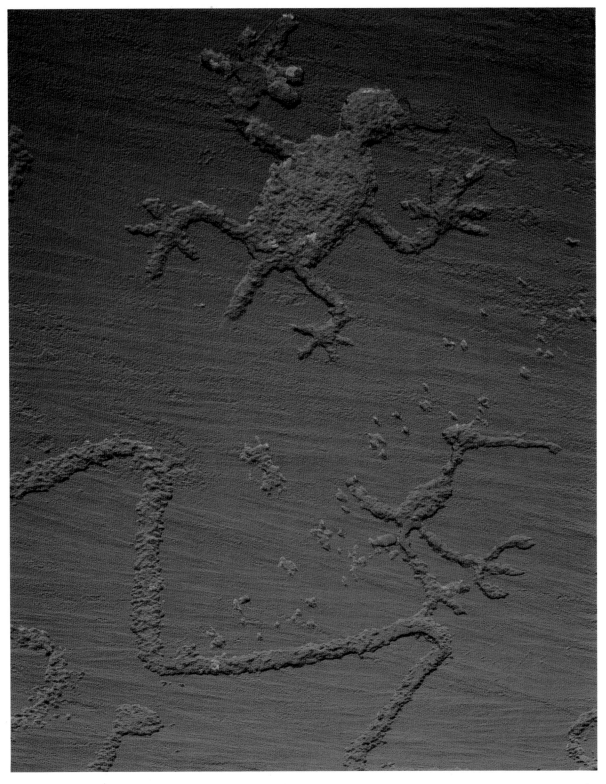

Some of the finest unvandalized examples of rock art in the United States are sequestered in Petrified Forest National Park. Although the Painted Desert seems harsh and barren, its short-grass prairie supported many people. The paths of Old U.S. 66 and now Interstate 40 follow Native trade routes. Petrified Forest was the source of petrified wood, which was widely traded for use in stone tools.

East of Petrified Forest National Park, an Anasazi drawing depicts a person holding what appears to be a pronghorn antelope within a crescent. The being's head is tilted slightly back as if looking at the running animal. A connection between hunter and prey seems apparent.

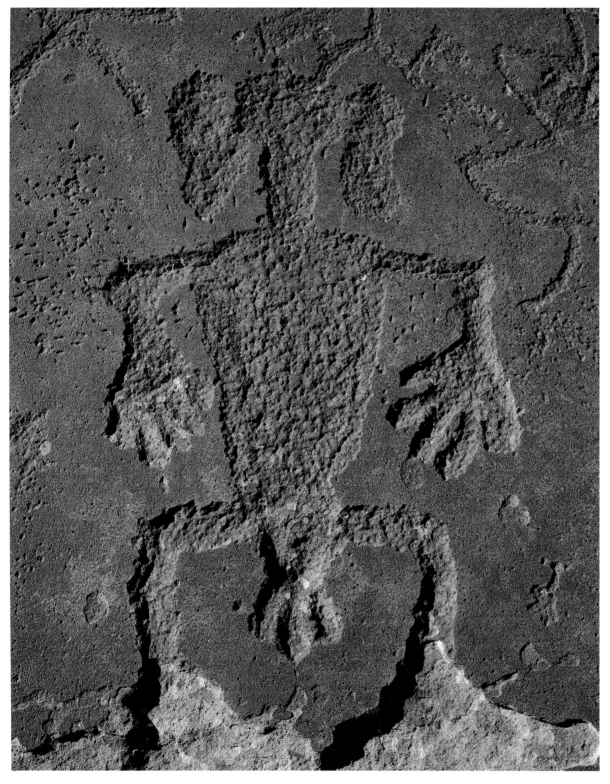

During Basketmaker times, approximately 100 B.C. to A.D. 750, Anasazi figures of humans were typically drawn large with drooping, exaggerated hands and feet and slightly tapered, trapazoidal bodies. Hair bobs and ornamentation were also common. This figure's coiled hair resembles that often worn by modern Hopi women before marrying. Desert varnish has mostly repatinated this figure from the upper Little Colorado River of Arizona.

A line of bighorn sheep marches across a sandstone boulder in the backcountry of Petrified Forest National Park. Since these Anasazi carvings were made, the boulder has slightly cracked. It rests on unstable bentonite clay of the Chinle Formation, which expands when moist and shrinks when dry. Forces of erosion are always at work, therefore reducing rock art's permanency.

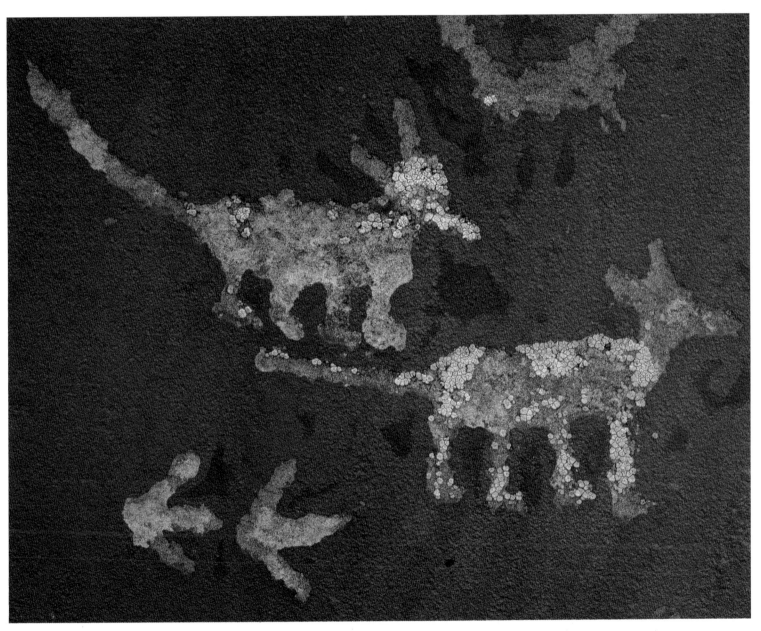

Anasazi petroglyphs of two coyotes and a pair of bird tracks contrast with the metallic desert varnish sealing Sonsela Sandstone in the Painted Desert of Petrified Forest. Lichens, which slowly break down rock, are able to gain a foothold on the chipped petroglyph surface.

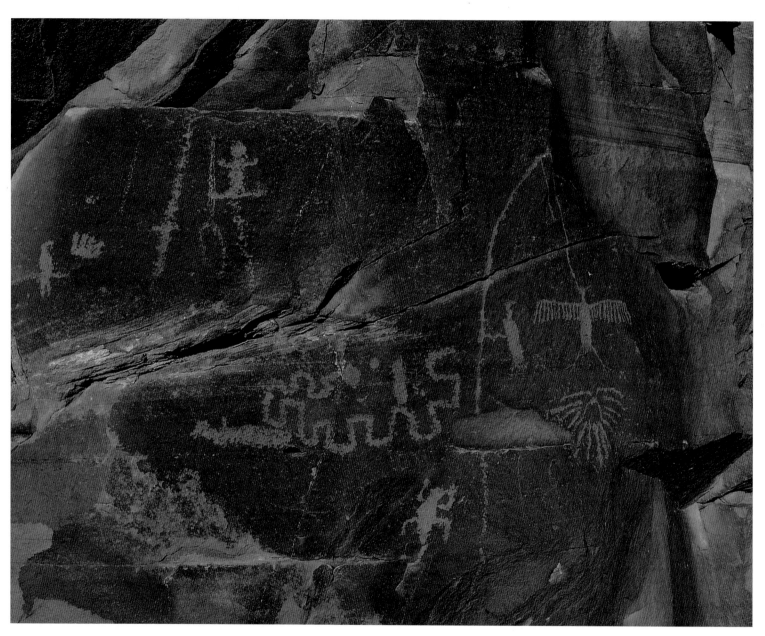

An Anasazi anthropomorph holding a long pole and rope raises a golden eagle from a northern Arizona nest. Higher on the same cliff, golden eagles raise their young. Hopis now lower young boys into eagle aeries to capture young birds for religious ceremonies.

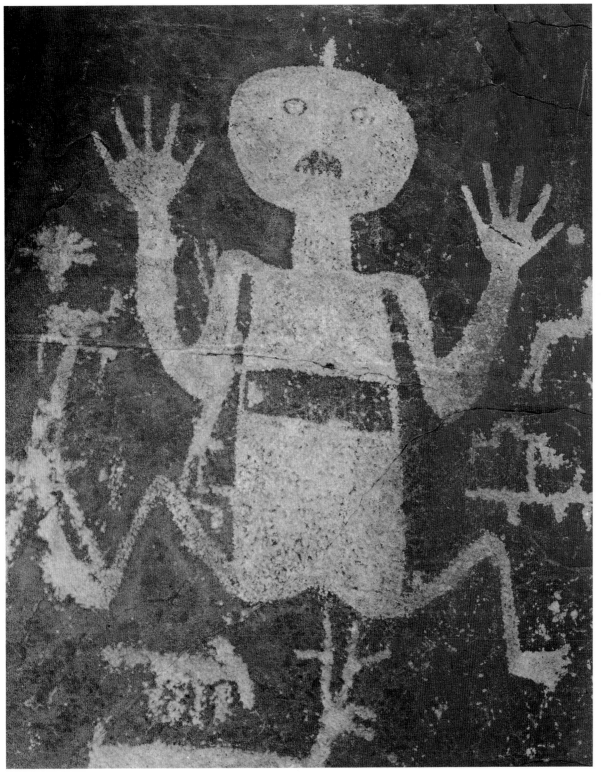

Precisely sculpted with a hammer stone and sharpened chisel, a human form cries out across the ages from a cliff southeast of Holbrook, Arizona. Anasazi people occupied the upper Little Colorado River region until the late fourteenth and early fifteenth centuries.

A hole naturally eroded in sandstone becomes the emergence point for a plant, perhaps corn, which then becomes connected to a human hand. Anasazi ties to the earth seem apparent. This petroglyph on a tributary to the Little Colorado River exhibits dint marks from recent reworking.

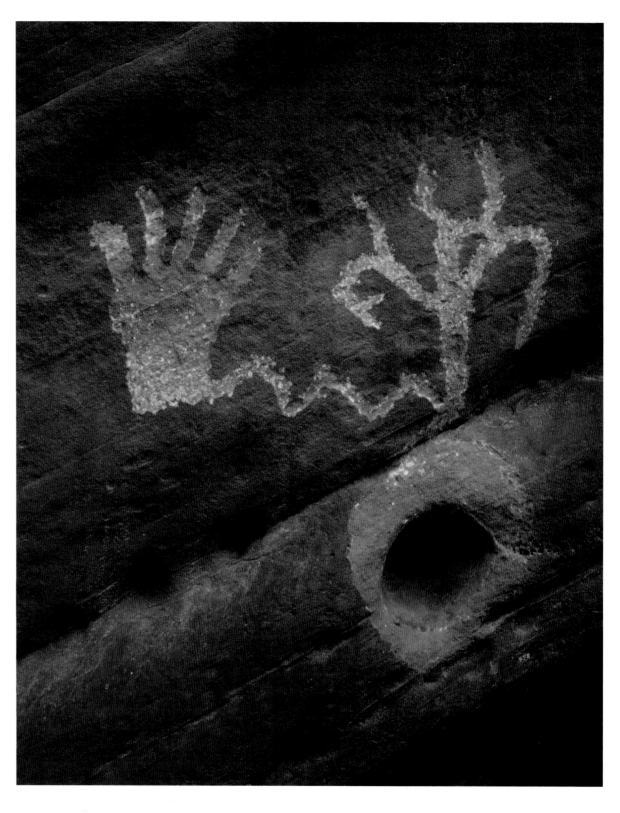

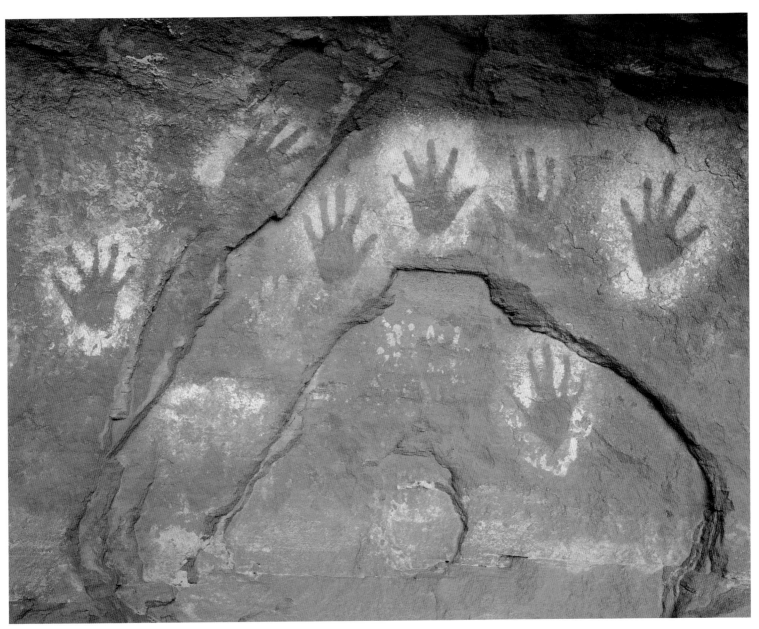

Handprints are signatures seen in rock art around the world. Hands were often painted with pigment, then pressed upon the rock. At other times, such as this Anasazi example from Canyon de Chelly, hands were done intaglio with pigment sprayed around the hand.

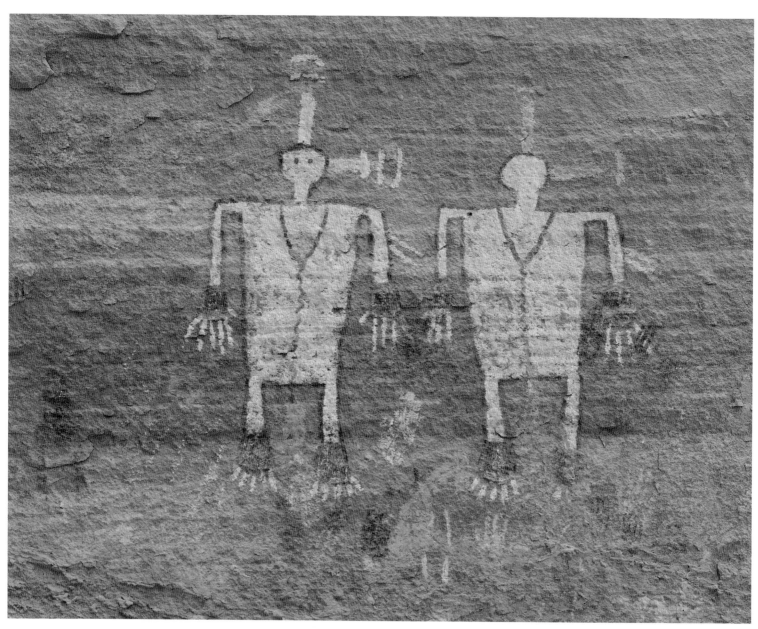

High above the floor of Canyon del Muerto in Canyon de Chelly National Monument, the Anasazi Basketmaker paintings show humans with appendages extending from the top and left sides of their heads. Similar anthropomorphs are carved on cliffs along the San Juan River in Utah.

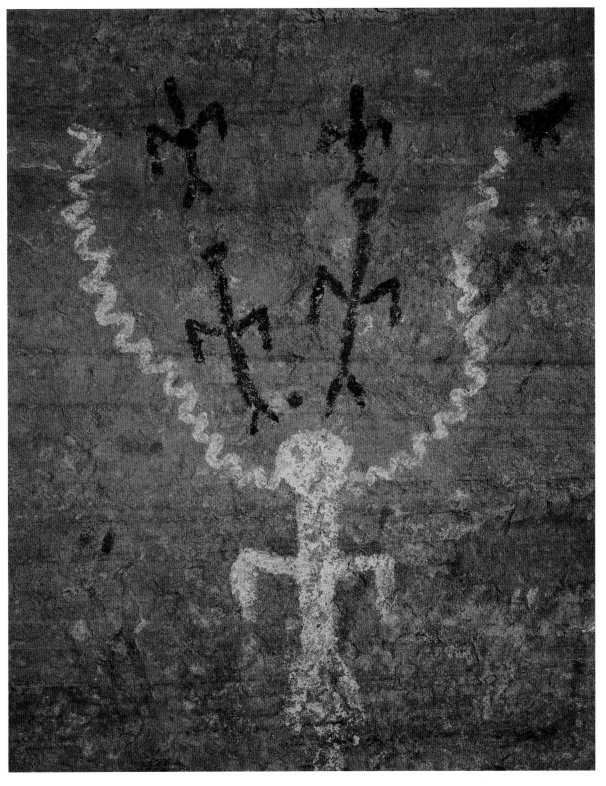

A cave in the Canyon de Chelly National Monument contains an unusual Anasazi Basketmaker pictograph. Some people have interpreted this polychrome painting as representing a shaman with power lines and four spirit people emanating from its head.

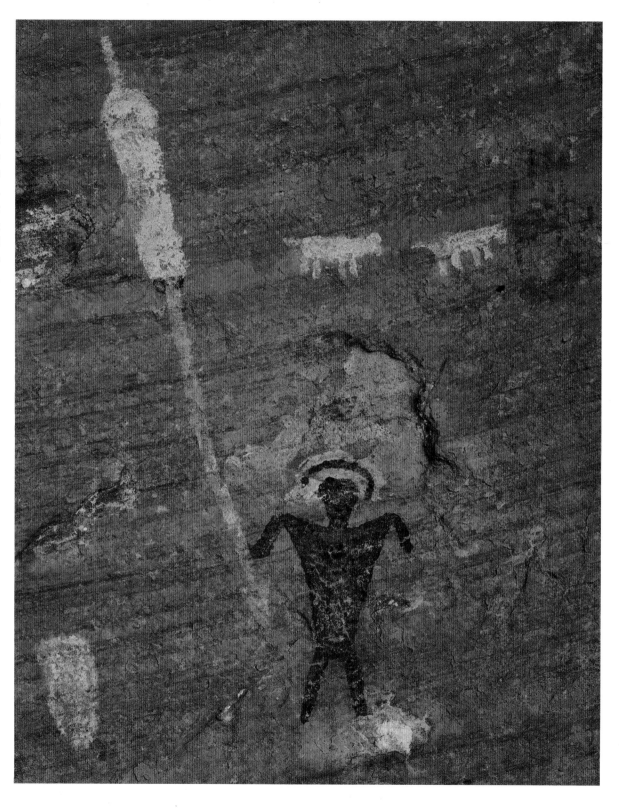

Arid conditions and sandstone caves with protective overhangs allow for excellent preservation of pictographs at Canyon de Chelly. Part of the Navajo Reservation, the national monument contains more than seven hundred archeological sites, with many having dramatic rock art panels.

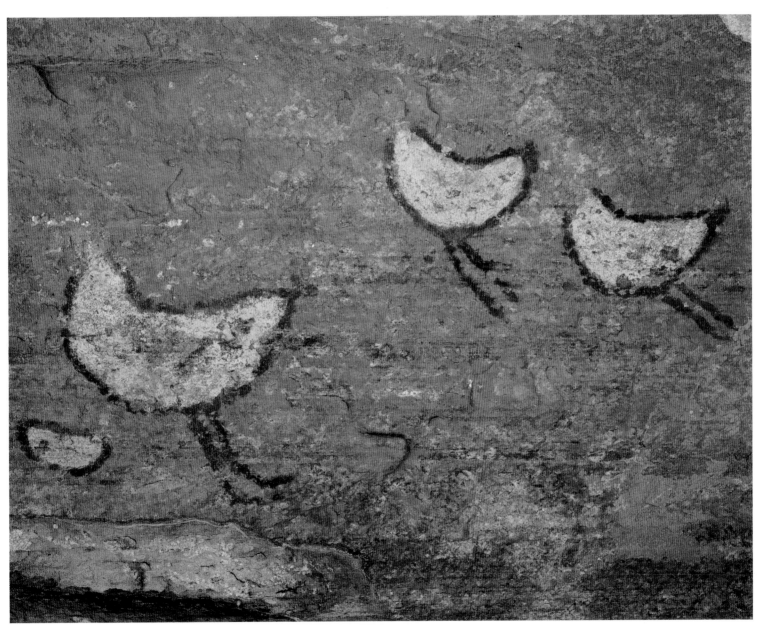

Three headless birds take flight in a Canyon del Muerto cave. Canyon de Chelly Anasazi depicted birds without wings. Essence of flight was obtained through dangling legs. Heads always may have been missing or were painted with a pigment that disappeared over the centuries.

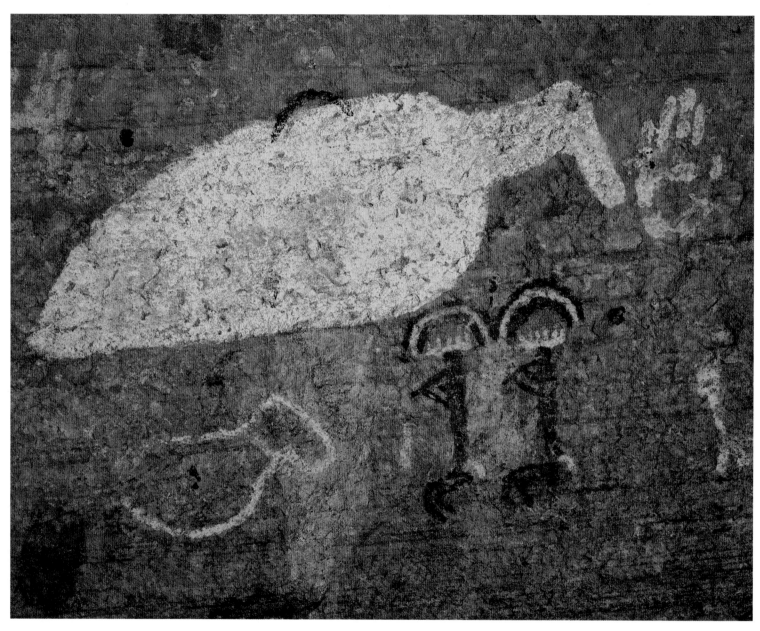

A great white bird looms over a pair of seated flute players.
The Anasazi of Canyon de Chelly frequently included turkeys
and ducks in their paintings, often placing the bird above
a head or actually replacing a person's head with a bird.

Archeoastronomers believe that pictographs of a star and crescent moon near Pueblo Penasco in Chaco Culture National Historical Park, New Mexico, may be an Anasazi documentation of the Crab Nebula supernova explosion in July of A.D. 1054. Some archeologists suggest other possibilities.

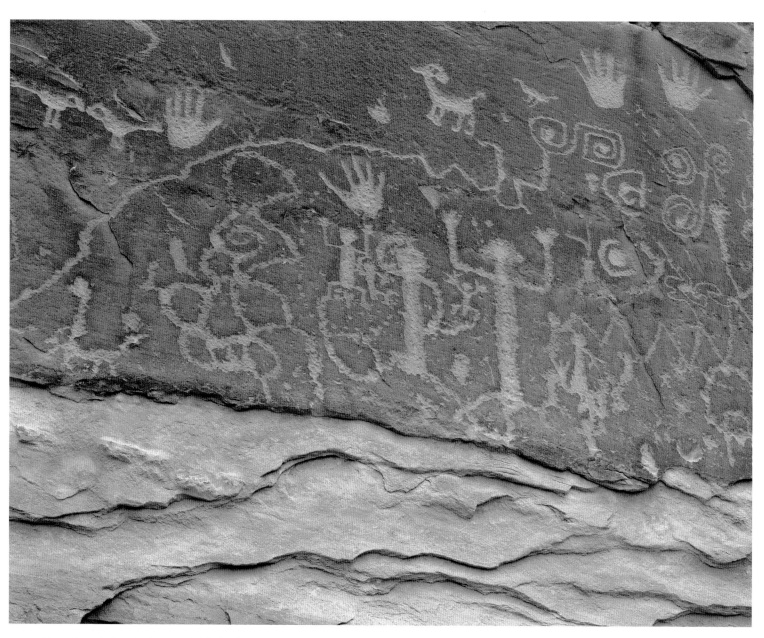

More than six hundred Anasazi cliff dwellings occur in Mesa Verde
National Park. Rock art, however, is somehwat unusual on the
high mesas. At Petroglyph Point of Chapin Mesa, an emphasis on
geometric shapes and stick-figure humans typifies late Anasazi artwork.

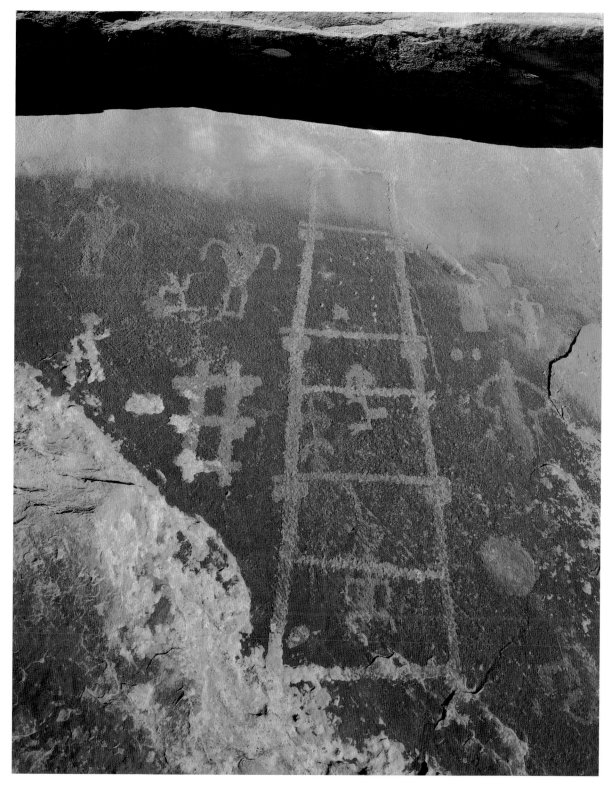

Poles and sticks were lashed together by the Anasazi to make ladders used for descending into ceremonial kivas and climbing into cliff dwellings. Original ladders, similar to the one carved here and more than eight hundred years old, were found in ruins of southeastern Utah.

The state of preservation in some ruins is remarkable. This keyhole entrance of a living quarters opens into the protected plaza shown on the opposite page. Body polish from people passing through the doorway is clearly evident on the rock walls and shelf of this Mesa Verda Anasazi dwelling in southeastern Utah.

Clay stucco walls are painted with a white bar and dot motif. The pattern repeats with the addition of zigzag lines on the outside sandstone cliff. Soot from many years of fires for cooking and heating blackens the ceiling of this cliff dwelling.

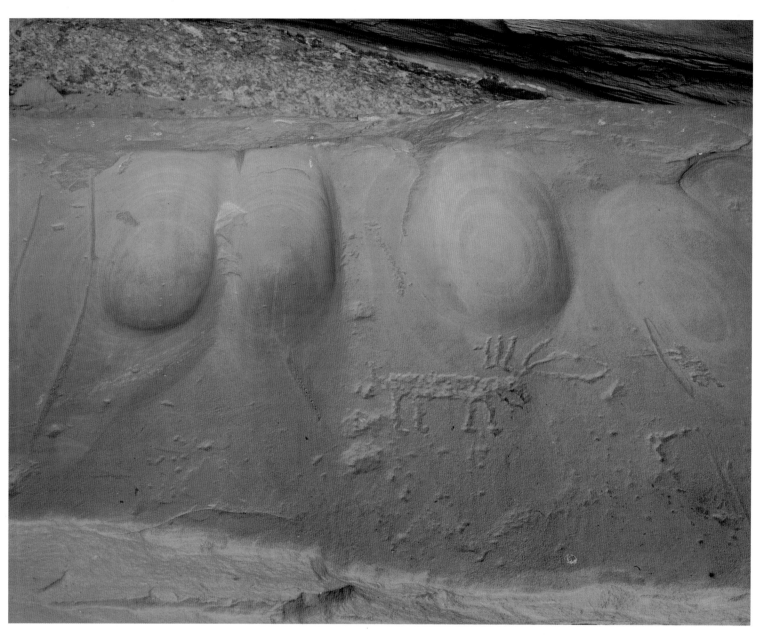

Well used metates for grinding corn meal are decorated with the petroglyph of a bowhunter shooting at an elk. This particular Southeastern Utah Anasazi ruin has a perennial spring that seeps in the back of its protective sandstone cave.

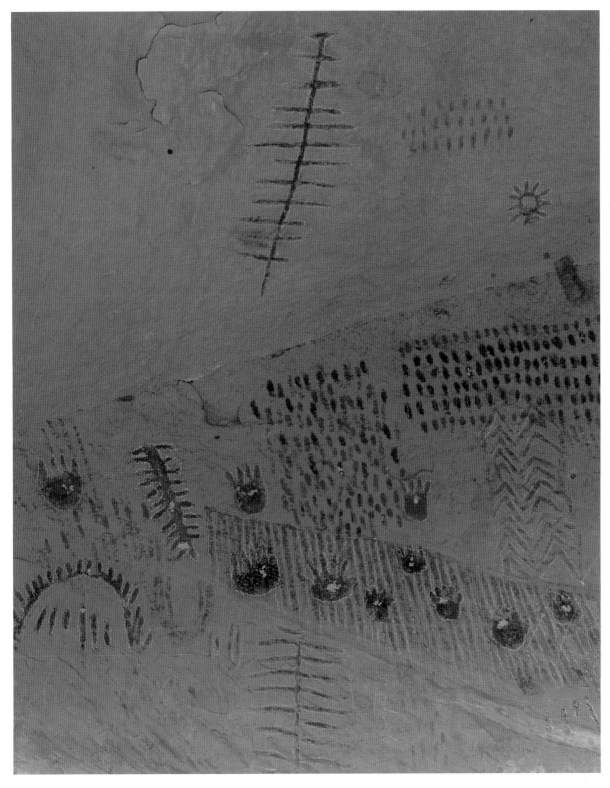

In a deep canyon slicing through Utah's San Rafael Reef, red and black paintings of the Chihuahuan Polychrome Abstract Style cover the walls of a shallow rock shelter. These Archaic paintings are likely more than two thousand years old. Similar designs occur at scattered locations in southeastern Utah and much farther to the south from the Alamo Hueco Mountains of New Mexico to the Guadalupe Mountains of Texas.

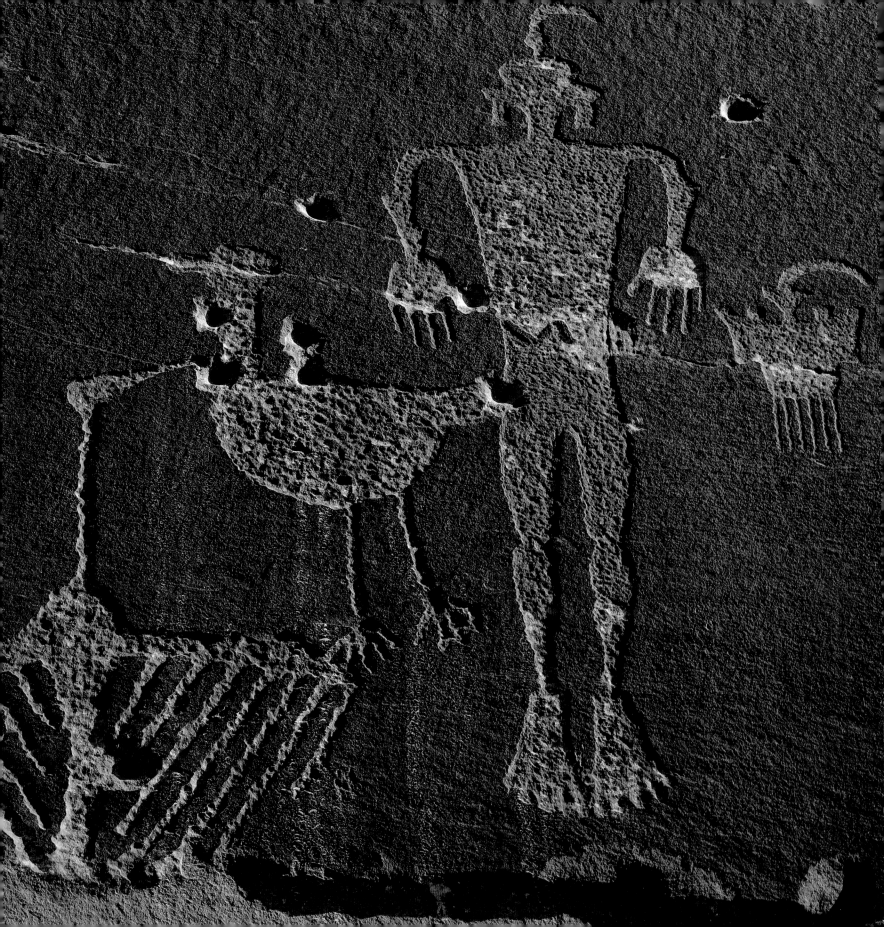

GREEN MASK

Petroglyphs cluster at the base of a sandstone cliff, stained raven-black with desert varnish. Pecked through the dark sheath rock, these symbols have marked the canyon walls long before Spanish names marked the maps of the San Juan River country. The Anasazi rock carver took care to achieve a realistic effect in the figure of a man by getting the details right, from hair bobs to the muscular definition of the legs. The skillful rendering of the petroglyph contrasts with the raw bullet holes that pockmark the cliff-rock in an aimless, shoot-from-the-hip pattern.

A flute player reclines near the man and a bird takes flight. With wings spread wide and long beak lifted, the glyph captures an instant that has lasted centuries.

As I face the wall, a sudden movement on the wall catches me off guard. Outstretched wings cast a shadow that floats across the rock face. I turn to watch a hawk glide by, completely silent. It passes once, twice, each time swooping closer before veering out of sight, its curiosity satisfied.

Below the Basketmaker-period site, a wash drains through a deep arroyo where beaver have dammed the creek bed, forming a series of narrow pools. Up-canyon sits a small ruin with its outer walls eroded away. Masons packed the rough-laid walls with more mud than stone, blending so well with the canyon they could pass for a geologic feature.

Pecked shapes climb along a thin ledge above it and spread onto the overhanging rock, unreachable from top or bottom. The petroglyphs trace the pre-Euclidian geometry of curving horn and zigzag snake. Darkly weathered, the ancient figures push the edges of the timescape far beyond the moment.

The last pictographs drawn run along the foot of the cliff. Scratched in charcoal, they show a man on horseback riding in the middle of a string of longhorn cattle. A line twists above his head like a lariat. Carved nearby is the name, "J. L. Butler Aug. 2. 1879." The cowboy arrives and the Indian record ends.

By the time I return to the pickup, the sun sits above the ridgeline to the west. Back on the highway I pass an old back-roads truck heading the other direction. Painted on the side are the words "Know Fear."

I turn off to the San Juan River and park next to the foot of a cliff at Sand Island. Petroglyphs, hard to make out in the flat light at the end of day, cover patches of the wall. A bighorn stands on its hind legs and plays a flute as a woman gives birth among a hundred forms pressing close together.

The masks I have come to see lie in this jumble of images, forcing me to hunt for them. Finally I spot one. The hair hangs long, sphinx-like, framing a face divided into bands. A small telltale loop protrudes from the top. The mask is not set off or given any particular prominence. It is a face lost in the crowd. A similar image appears high on a wall of Grand Gulch above the ruins of an Anasazi cliff dwelling. Known as the Green Mask, the pictograph shows a face painted with bands of green and yellow. Other glyphs on the same wall depict headless people.

Some archeologists believe these masks represent trophy heads. They reflect the idea that the slayer is honored by the honor he shows the slain, like an antlered head hung on the den wall. But the petroglyph heads could represent artifacts of any belief from witchcraft to ancestor worship, wherever a bond is recognized between the living and the dead.

Back on the highway, I approach a slow-moving pickup. My headlights flash on a set of antlers poking up from the bed of the truck like the branches of a tree. Passing, I glance at the severed head of an elk, staring into the night with eyes opened wide.

Next day a trickle of water rises briefly from the floor of Grand Gulch before sinking. Fresh deer tracks trail across the

Left: *Gunfire has marred San Juan Basketmaker Style Anasazi petroglyphs.*

Above: *The Green Mask is a face painted with bands of green and yellow.*

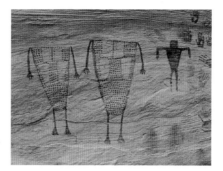

wet sand. Cottonwood leaves, still clinging to the branches, rattle with each shift of wind.

Our party climbs to the Blue Man site, named for a pictograph with an unusual blue tint. I've come here with Fred Hirschmann and Randi McPheron from Alaska, and Jennifer Whipple and Rick Hutchinson from Yellowstone. We descend a sand ridge perched on a high shelf above the creek. A path takes us along the base of the cliff and past a phalanx of armed men pecked into a wall at the entrance to the site.

The smooth face of the cliff climbs hundreds of feet skyward above a mantle of fragmented boulders. The wall arches high overhead, forming a massive alcove that shelters the rock art panel from the elements.

Working along the foot of the cliff, I pass pictographs painted with red, white, and yellow pigments. Human figures stand among the birds, animal pelts, and feathered staffs. Some of the people wear elaborate headdresses, and one appears to be undergoing a vision that rises smokelike from its head. Most of the anthropomorphs face forward with their right hands raised in the universal gesture of greeting, a wave. They have stood here greeting an empty canyon for a thousand years.

In the early 1970s scientists at NASA sent a Pioneer spacecraft outside the solar system. The first human artifact to enter interstellar space carried a message onboard. Etched onto the golden surface of a plaque was the image of two naked humans, a man and a woman. The man stood with his arm raised in a greeting to the cosmos.

We send a message on a trajectory we hope takes it into the realm of unknown intelligences, otherworldly beings. These are the spirits of our time. Perhaps the Anasazi left these drawings for their own supernatural beings to find, only to have us show up a thousand years later.

Painted with finger tips, headless human figures are close to the Green Mask.

Rick Hutchinson, geologist, tries to keep the enthusiasms of the glyphers in perspective. He calls rock art graffiti, insisting that humans add nothing to the beauty of bare rock. "That's true rock art," he says.

Wandering up-canyon, I wait for the others to return from the Blue Man site. Their voices drift up the canyon, amplified by the curving rock wall. We gather at the foot of the route leading to the rim, weighing the options of leaving now and reaching the trucks before dark or photographing another site. For Fred there is no choice. Fred and I inch across a narrow ledge on our stomachs as we push the camera gear before us. We reach a panel of pictos with a man painted in bright vermilion and a head as pointed as a spade in a deck of cards.

Many of the human forms have broad shoulders, tapering to the waist, and wear headdresses and necklaces. This San Juan Anthropomorphic Style is typical of Basketmaker II times. Later paintings cover the earliest figures. Images merge in an overlay of pigments, becoming a collective memory where nothing is forgotten.

Some of the original pigments have lasted, while other, fugitive colors have disappeared. The human form of one pictograph has faded over time, leaving only the green and white of a tunic, a string of beads, and a belt. All that remains is an empty set of clothes, an invisible man.

Along the base of the cliff lies a set of strange mud drawings of horned sheep and knob-headed people. A bend of the canyon has become an eddy in the flow of time. Figures drawn with mud that dried a thousand years ago still cling to a canyon wall, outlasting the very way of life of those who left them.

We climb out of the gorge at the close of day onto the knobby rimland. It is wild slickrock country, scoured by sand-charged winds. Across the canyon, the Altar of the Sun burns red. For a moment, the air fills with a light that grows in intensity, as if it were dawn instead of dusk. But it fades as quickly as it came.

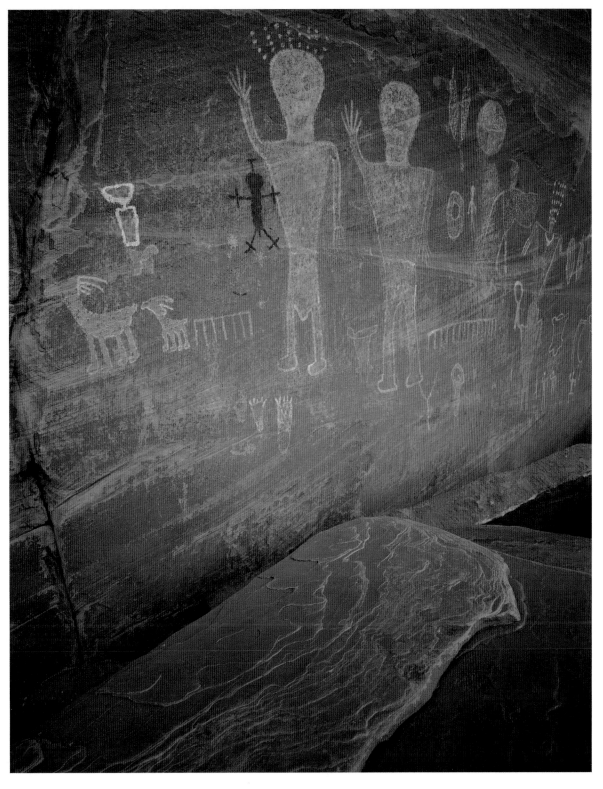

In what might be considered the universal greeting, two Anasazi figures raise their hands deep within Utah's Grand Gulch. Overseen by the Bureau of Land Management, the Grand Gulch Primitive Area contains many pristine ruins and collections of rock art.

An animal mask and flowering yucca are fine examples of San Juan Basketmaker petroglyphs in southeastern Utah. Yuccas were important plants to the Anasazi. The fibers were woven into sandals, baskets, bags, and aprons. Fruits were likely boiled or baked before eating.

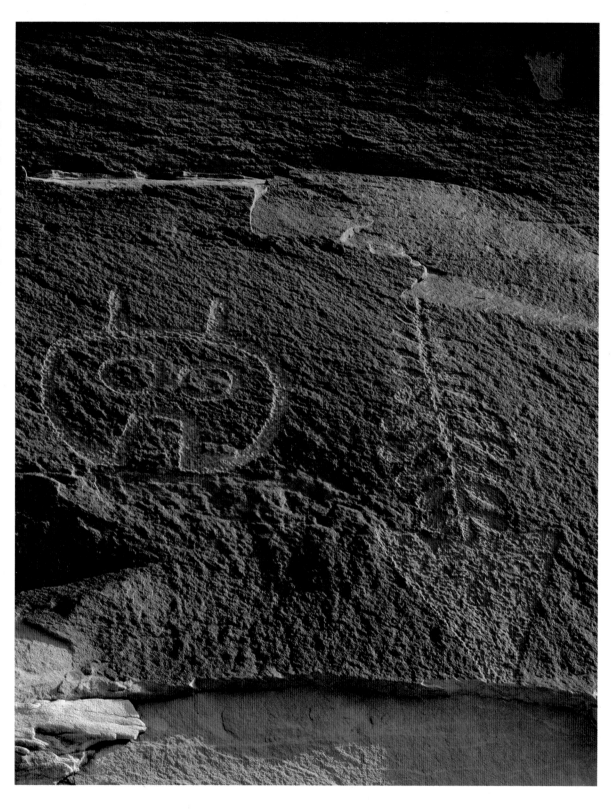

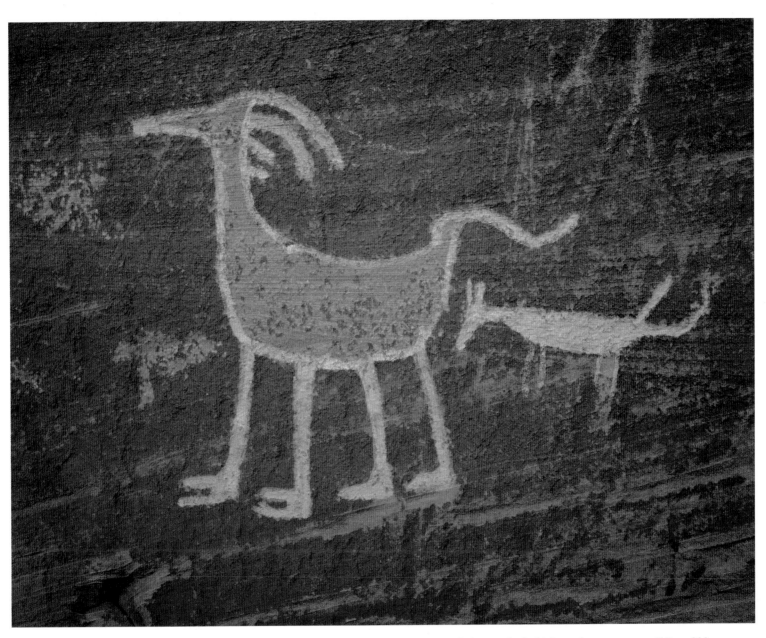

*An Anasazi pictograph of a bighorn sheep appears as if it could have
been painted yesterday. Depictions of atlatls on the same Grand Gulch
panel suggests the painting is at least fourteen hundred years old.
Nearby, drawings made entirely of mud still adhere to the canyon walls.*

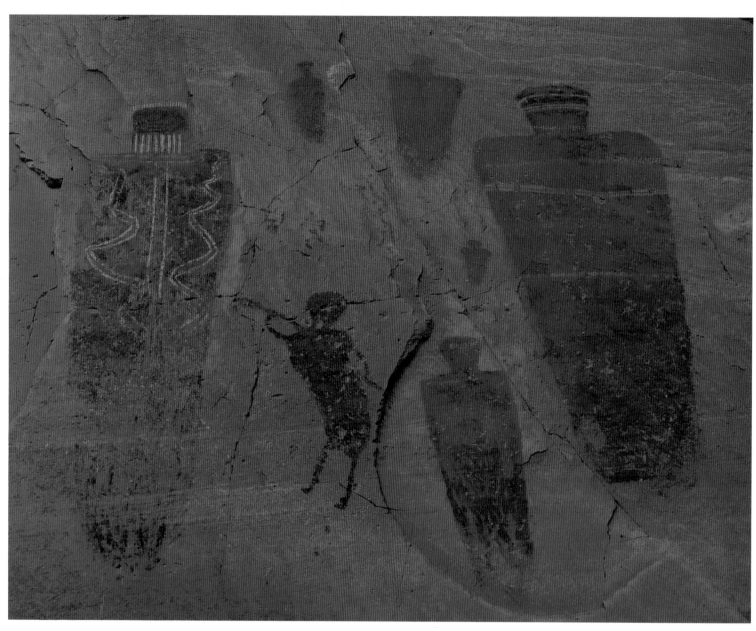

The Great Gallery, located in Horseshoe Canyon of Canyonlands National Park, Utah, is the type site for Barrier Canyon Style pictographs. The looming, anthropomorphic bodies, some over six feet tall, lack arms and legs, but often wear head and body decorations.

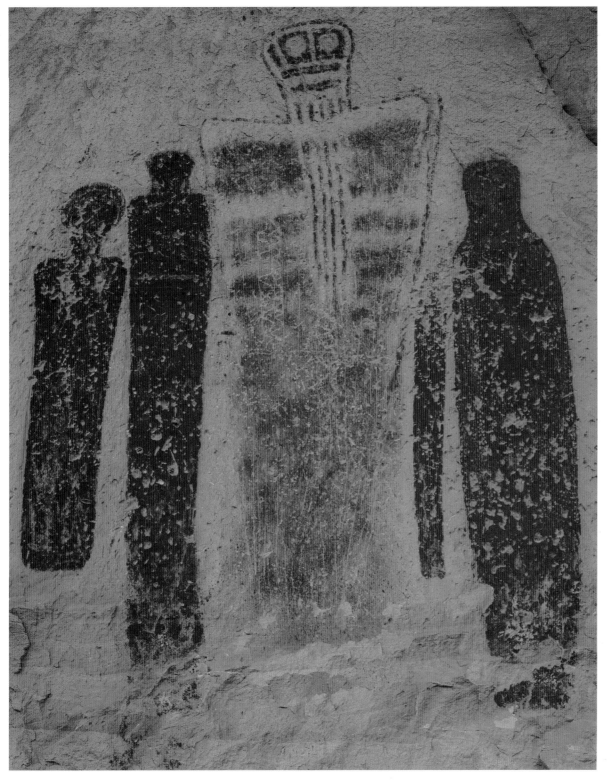

The Holy Ghost panel of the Great Gallery likely contains supernatural elements and may represent shamanistic art. After painting, the largest figure's body was further decorated by scraping away pigment. Extensive pockmarks stippling all the figures suggest a ritualistic throwing of sharp objects against the paintings.

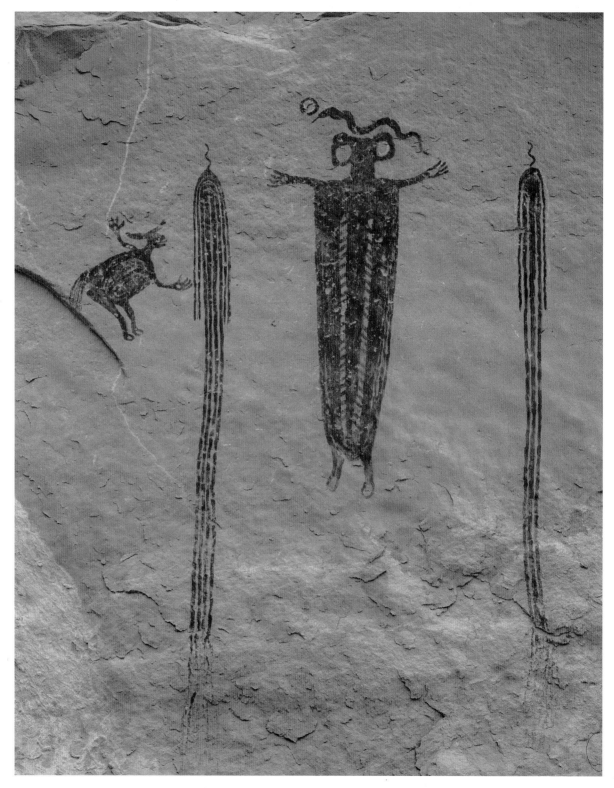

A fine set of Barrier Canyon Style paintings decorates a sandstone wall of Utah's San Rafael Swell. The rust-red pigment, derived in part from the iron oxide mineral hematite, is extremely durable. By chemically bonding with the rock, these ancient paintings have withstood fifteen hundred to perhaps more than three thousand years of weathering. Most of the coloration was applied with fingertips. A yucca fiber brush may have been used for painting fine details like the snake's tongue.

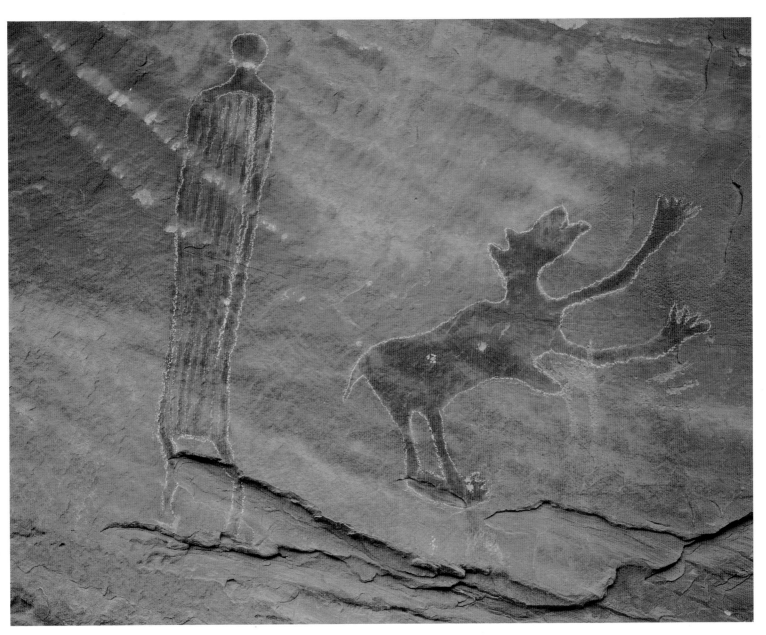

Many Barrier Canyon Style panels, such as this one from the San Rafael Reef, depict dogs in close proximity to shamanistic anthropomorphs. Approximately one hundred Barrier Canyon Style sites are known in southeast and southcentral Utah and adjacent portions of Arizona and Colorado.

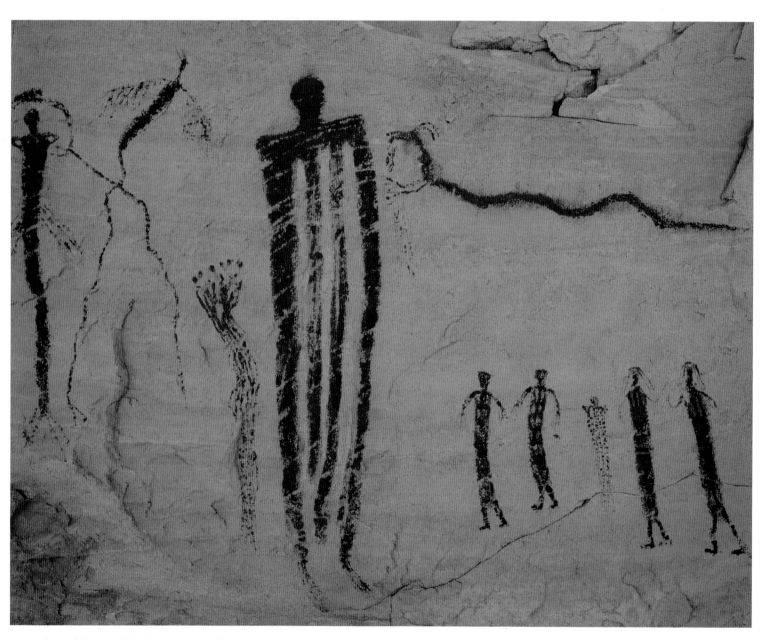

Central figures of Barrier Canyon Style paintings are often surrounded by animated animals and humans. In the San Rafael Swell, a snake-like figure with front legs, horns, and drooling mouth approaches a looming anthropomorph. Beyond, a rooted bird takes flight.

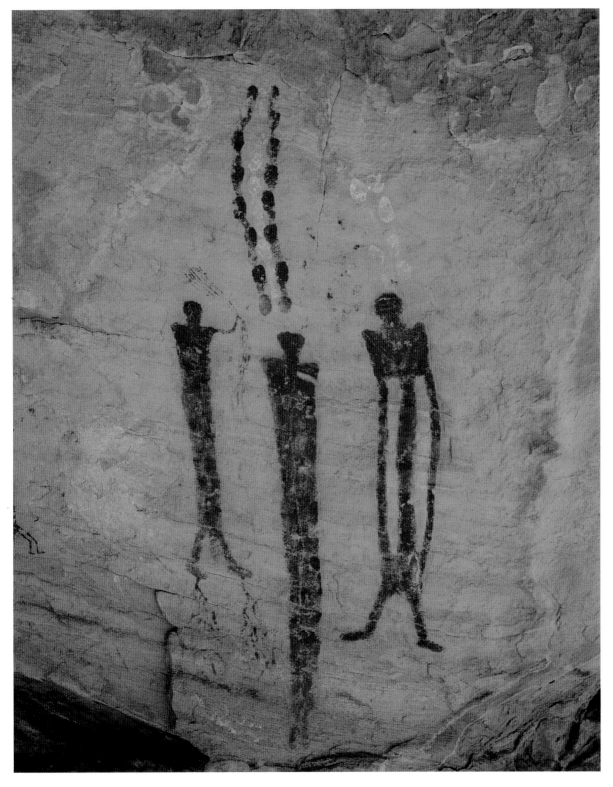

At the same site shown on the opposite page, three figures stand grouped together. The left being holds a swath of sticks and has feet rooted to the ground. Similar narrow-bodied beings often holding bundles of sticks are the hallmark of the Pecos River Style paintings in Texas. Much mystery surrounds the dating of Barrier Canyon and Pecos River pictographs. Perhaps these Archaic period nomadic hunters had connections across the wide range of Southwestern deserts.

The Needles District of Canyonlands National Park has rock art described as the Faces Motif. In preparation for painting, portions of the rock surface were smoothed and carved. Then elaborate decorations were placed on the torsos of broad-shouldered beings.

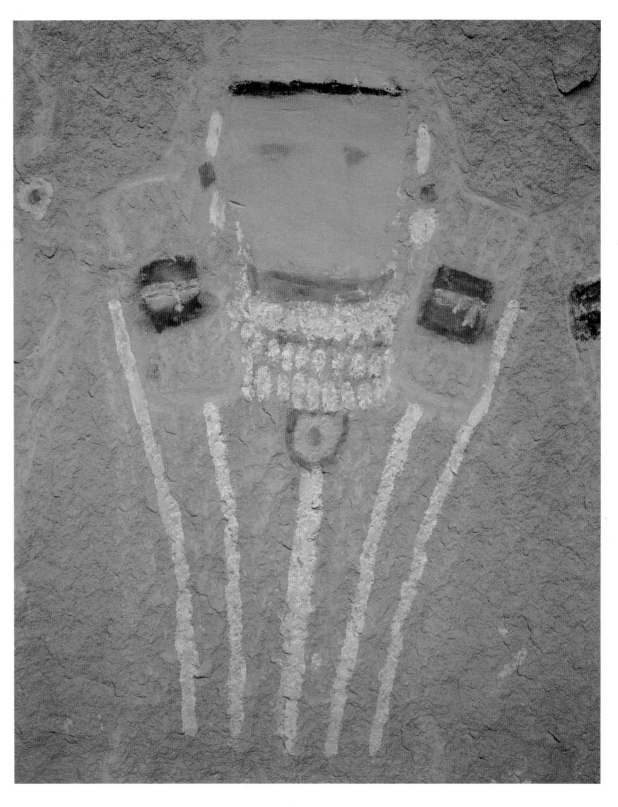

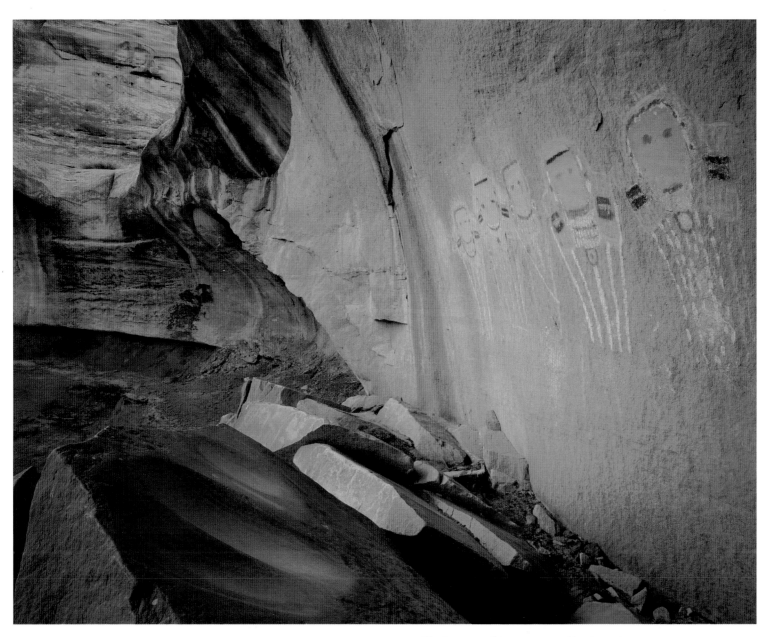

*The Faces Motif incorporates a blending of Anasazi and Fremont
cultures. The paintings resemble Fremont clay figurines exca-
vated at sites to the west and north. The placement of paintings
and metates in a beautiful alcove suggests the site was a shrine.*

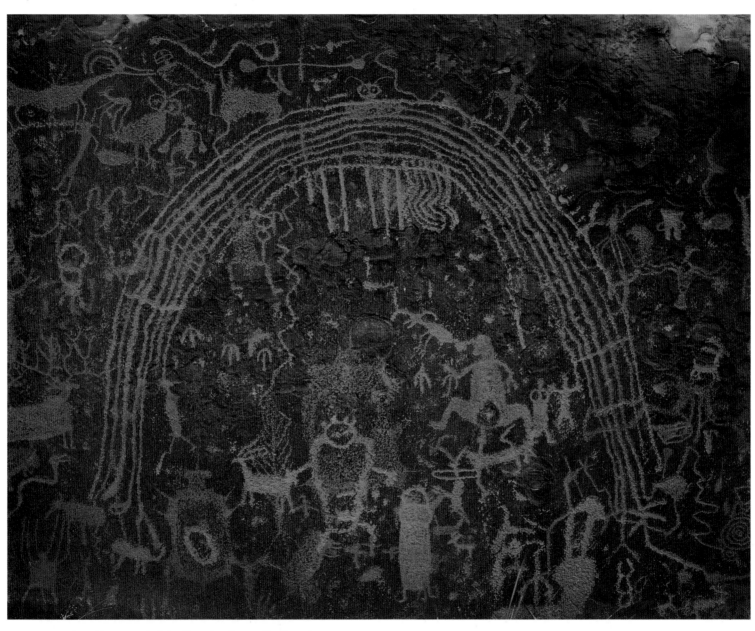

West of Utah's San Rafael Swell, an intricate collection of petroglyphs depicts a rainbow arcing through assorted animals, people, plants, and mythical beings. The activity of this panel imparts a feeling for the bounty and diversity of Fremont people's world.

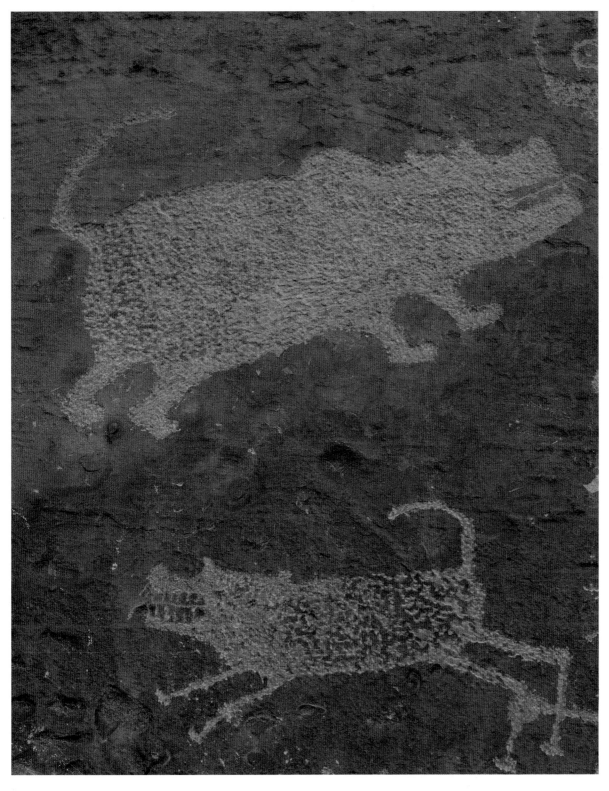

To the upper left of the rainbow panel are a series of ferocious looking animals. Some appear like mythical monsters; others may be angry dogs. A tall vertical line and the exfoliation of rock separates the rainbow section of this panel from the area of more sinister elements.

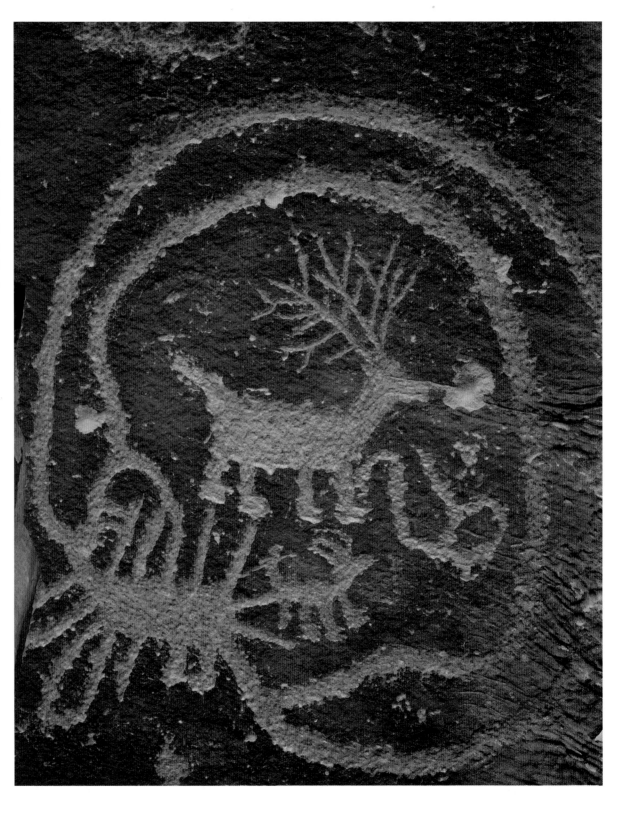

Northwest of Price, Utah, the Nine Mile Canyon area preserves a diverse selection of Fremont rock art. Deer and sheep appear on most panels. Sadly, a thoughtless individual has used this ornate deer for target practice. Gunfire does irreparable damage in a fraction of a second.

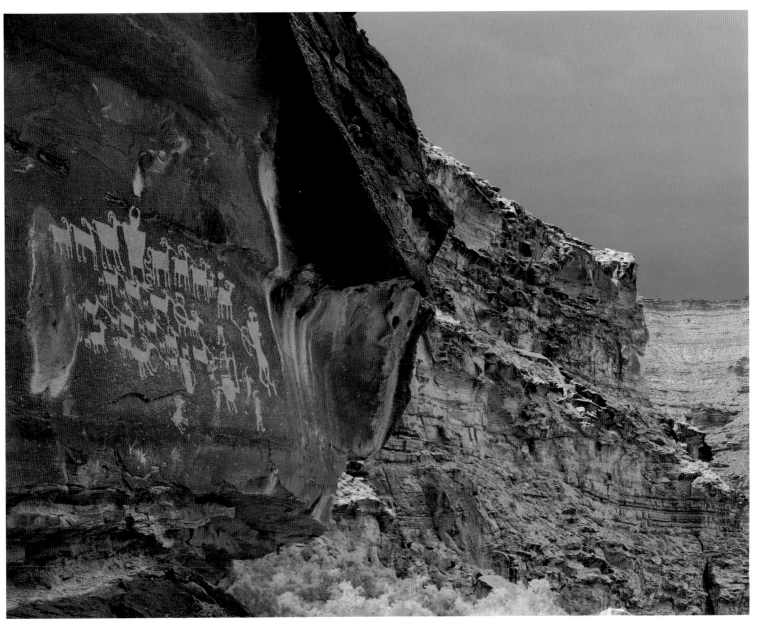

The Fremont culture flourished over most of Utah west of the Colorado River. Like their Anasazi neighbors to the south, the Fremont raised corn, squash, and beans. Fremont people placed a heavier emphasis than the Anasazi on wild food gathering as depicted in the Hunter's Mural.

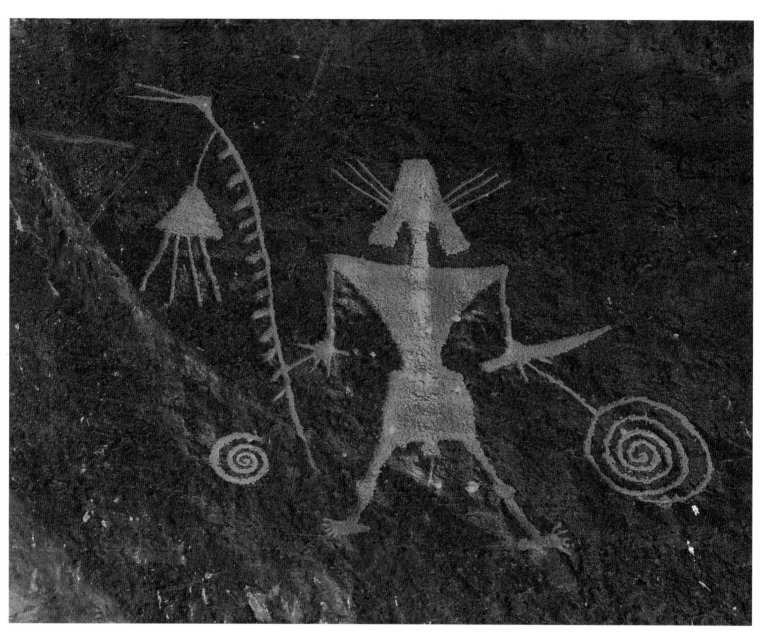

In western Colorado, a Fremont figure holds a knife blade and is connected to a bird-headed staff with a dangling pouch. An extremely similar staff was excavated from an Anasazi Basketmaker site at Marsh Pass, Arizona, some two hundred miles to the southwest.

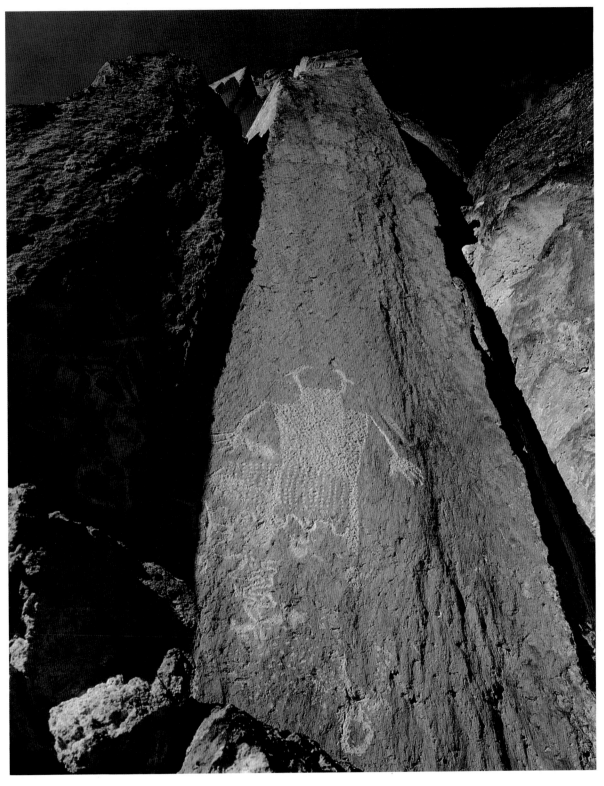

Volcanic cliffs of welded ash and tuff provide a dramatic setting for rock art at Fremont Indian State Park in Utah. Typical of Fremont anthropomorphs, this figure is trapezoidal in shape, has broad shoulders, lacks a neck, and wears horns for a headdress. The Fremont people abandoned the Clear Creek Canyon approximately eight hundred years ago.

Pairs of negative hand prints decorate the wall of a sandstone shelter above Indian Creek in Southern Utah. A couple of methods for making intaglio images are possible. The area around a hand placed on the wall can be carefully wetted. Then, through the use of straws passing through a gourd containing dry pigment, the powder can be blown to outline the hand. In Australia, aboriginal artists mix pigment with saliva in their mouth and then spit the mixture over a hand held fast to the rock.

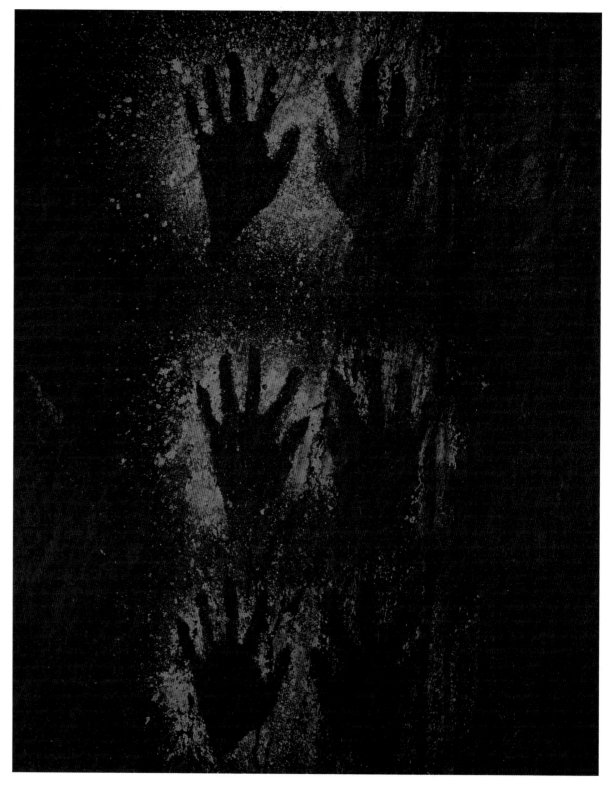

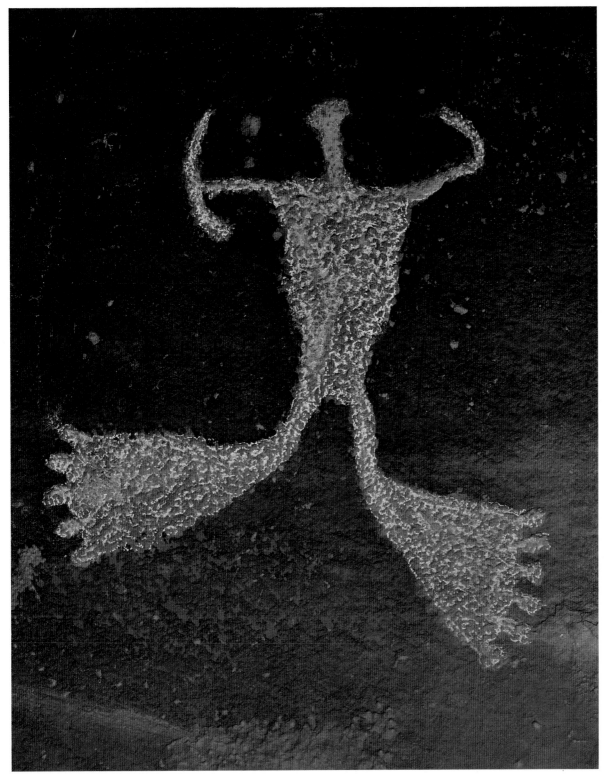

Also along Indian Creek, a large-footed person with bow exhibits a blending of Fremont and Anasazi cultures. Six toes on the figure's left foot is a curiosity. The drawing has been damaged by chalking the interior to make it stand out from the bedrock. Oils from human hands hurt living bacteria that create desert varnish. Charcoal rubbing and latex casts further damage rock art by removing bits of the rock. The best way to enjoy rock art is to look at it and record the designs with natural light photographs and field sketches.

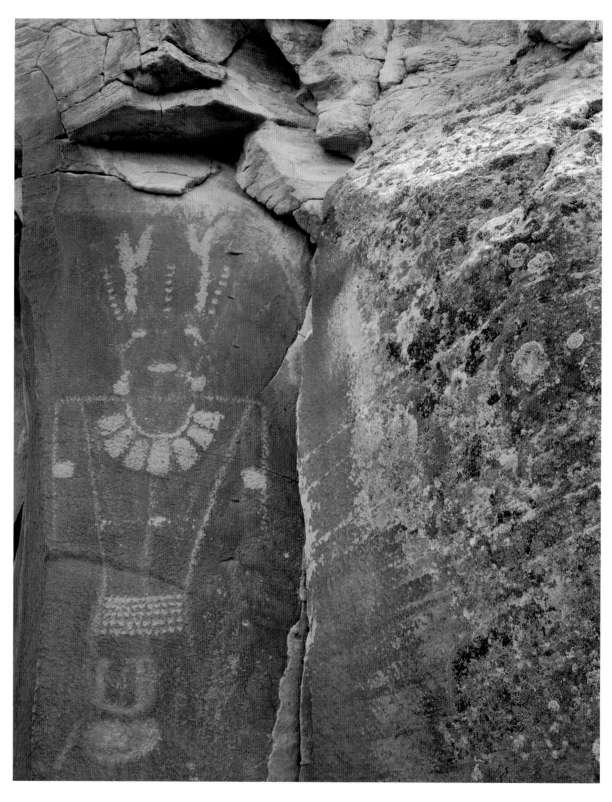

Fremont petroglyphs of the Classic Vernal Style are chiseled life-size and come highly decorated about the head, neck, and torso. The Dry Fork of Ashley Creek and Dinosaur National Monument in northeastern Utah's Uinta Valley contain spectacular collections of these large drawings.

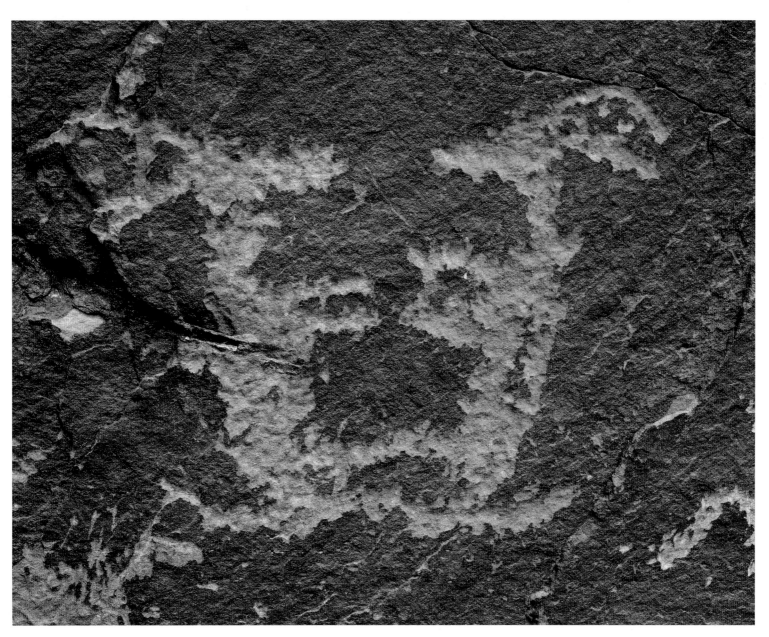

Two bighorn sheep sit upright facing each other on a Fremont panel from Nine Mile Canyon. Another motif occasionally encountered is two-headed sheep. The number of times an animal appears in a culture's rock art may reflect the animal's relative importance to the people.

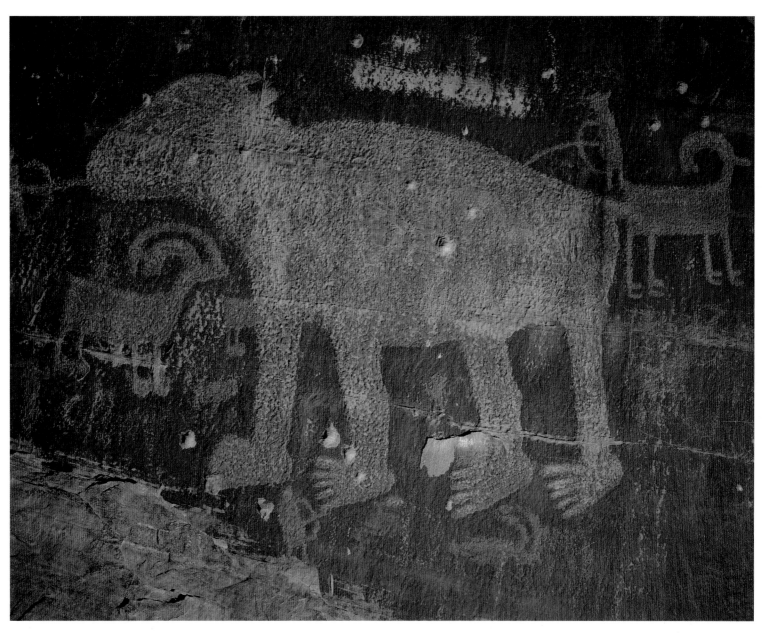

Bears are one of the more unusual elements seen in either Fremont or Anasazi rock art. This example occurs on a wall above the Colorado River near Moab, Utah. Bear tracks, however, are frequently carved and, in some cases, may represent clan symbols.

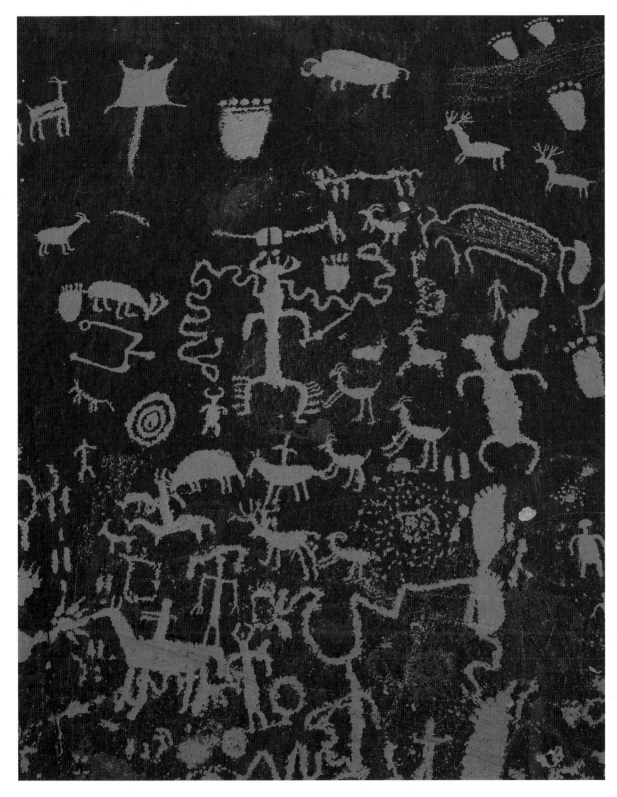

Newspaper Rock State Park in Utah has a fine panel of historic Ute petroglyphs carved over earlier Anasazi drawings. It has been suggested the bowlegged figure with lines radiating from its head may show a curious blending of Native culture with that of Euro-American origin. Power lines emanating from the head and an elaborate headdress are symbols frequently seen in prehistoric rock art. Fringed chaps covering the bowlegs and a riding whip or quirt held in the figure's hands could be examples of Euro-American influence after A.D. 1800.

Along the Mancos River on the Ute Mountain Tribal Park in Colorado are many fine examples of Ute Representational Style artwork. Painted from A.D. 1880 to 1950, the figures often depict women of the tribe in long red dresses. Many of the paintings are attributed to Chief Jack House who lived in the canyon. Other artists likely copied his style.

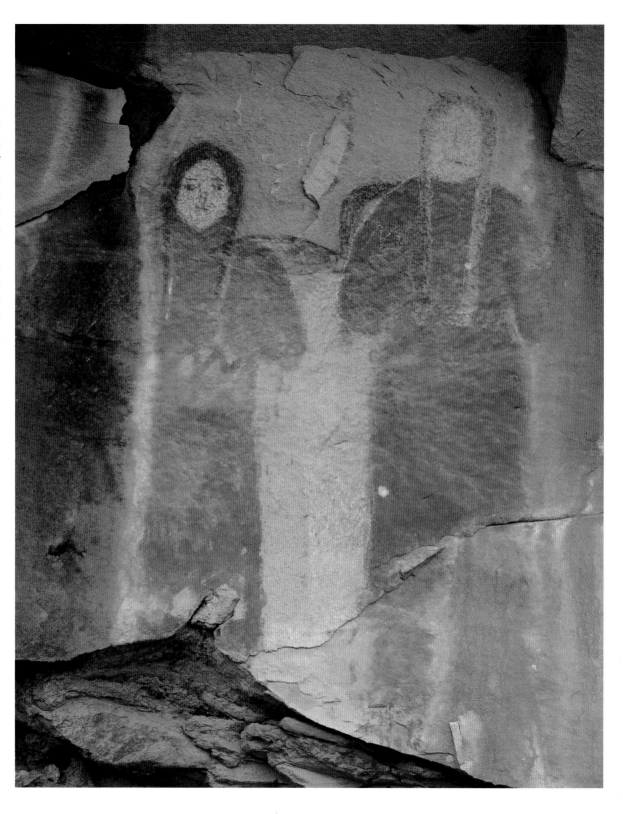

HAND-IN-SUN

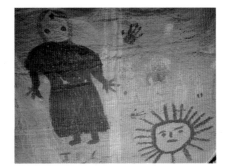

Heavy runoff has filled the Mancos River, bank to bank, as it rushes along the foot of Mesa Verde in southwestern Colorado. The river drains the homeland of the Ute Mountain Utes, a place filled with ruins and rock art. Tribal guide Tommy May parks the truck, letting his passengers stretch their legs. Visitors to the Ute Mountain Tribal Park must go with a guide. Wearing a baseball cap and a T-shirt with a flute player logo, Tommy climbs a talus slope to a red pictograph of a Ute warrior painted in historic times.

Before settling on the reservation, the Utes lived in tepees and ranged on horseback through the mountains, plains, and plateau country. The guide stands looking at the rock painting of a Ute dressed in a style of clothing influenced by the Plains Indians. Red paint streaks the face of the warrior, framed by long braids falling to his waist with two red feathers tied in his hair. Traditionally, the Utes have considered red a sacred color.

"When I see this," Tommy says, choosing his words carefully. "I am proud of what my people did."

Returning to the truck, we head up Mancos Canyon. Soon Tommy stops at the homesite of Chief Jack House. Born before the turn of the century, he was the last traditional leader of the Ute Mountain Utes and one of the last pictograph makers. He also encouraged the Ute people to set aside Mancos Canyon and its archeological resources as a tribal park.

The Ute leader's work covers the overhanging cliff behind the homesite. Among the figures are a woman, a buffalo, and a cowboy on horseback. Chief House painted many of the rock art panels with the red dye used for marking sheep. This reservation period rock art is known as the Ute Representational Style for the detailed naturalism of the images.

We walk past the chief's hogan site, a blackened circle with charred ends of posts jutting from the ground. After Jack House died in the early 1970s, Utes burned his home to keep outsiders from disturbing the spirits still present.

Continuing up the canyon, we pass a panel with a red handprint above a sunburst. Known to the Utes as Hand-in-Sun, Chief House left his pictographic signature here at Female Cave. The figure of a woman in a solid red dress stands next to it. The guide tells us the red dots on her cheeks and her forehead show how women once painted their faces to prevent sunburn. "Early sunscreen," he says.

We reach Kiva Point at the south end of Chapin Mesa. A couple of miles to the north in Mesa Verde National Park lies Cliff Palace, the largest cliff dwelling in the Southwest. Richard Wetherill discovered the ruined village in 1888, after first hearing about it from a Ute named Acowitz. Wetherill ignored his warning not to enter the ruins and disturb the spirits.

Anasazi Indians lived at Kiva Point for seven centuries. Mounds indicate where they built two multistory villages, each with a great kiva. Ruins of several smaller pueblos and two towers are nearby, and well-preserved cliff dwellings are in the upper reaches of the canyon. Tommy believes the Anasazi abandoned the region around A.D. 1250 when a long drought killed their crops. "The water just dried up," he says.

Anasazi petroglyphs mark the sandstone cliff above the site. After viewing the rock art, I walk with the guide over the rubble of the old pueblos. Tommy looks around, searching for something among the pieces of pottery. "I wonder where they threw their Tupperware at?" he jokes. "What did these people do? No TV, no cartoons, no pickup, and no plastic."

Rains have washed out the road past Kiva Point, forcing a return to the Ute town of Towaoc where most of the tribe's fifteen hundred members live. On the drive back, Tommy tells about a tribal prophecy that one day the Anasazi will return. He looks back at his passengers, coated with gray dust blown into the truck. "Here they are," he says with a smile. "Ghost riders."

Sheep marking dyes were used by modern Utes for Mancos Canyon paintings.

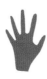

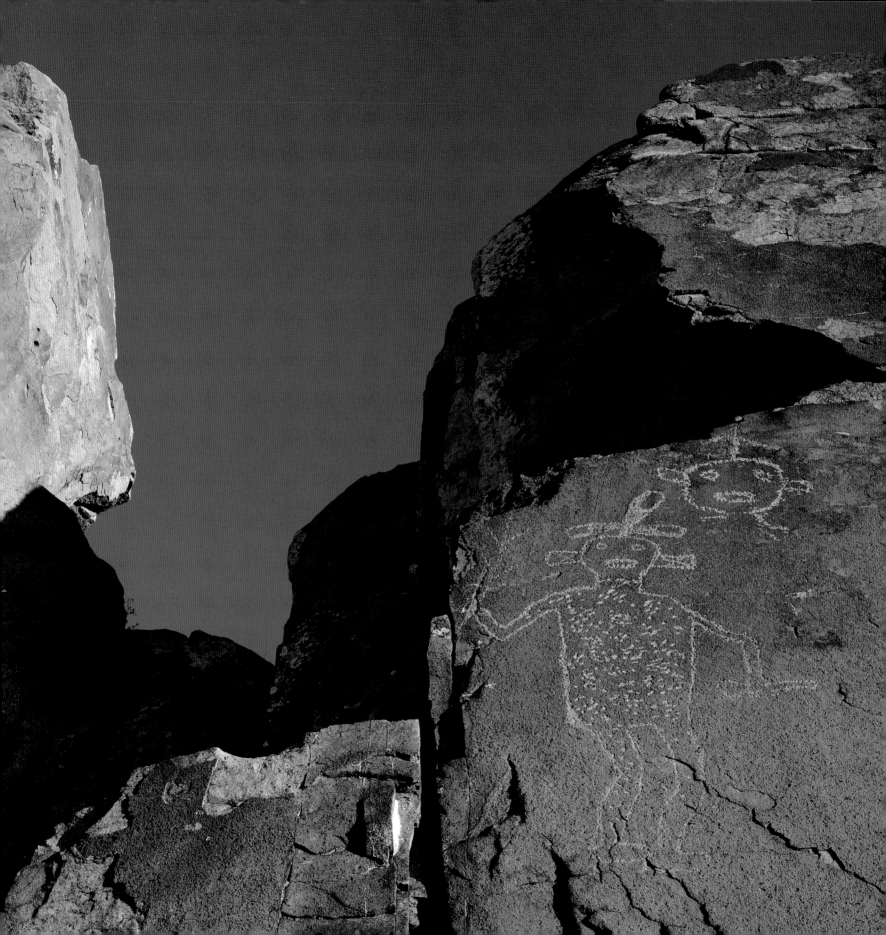

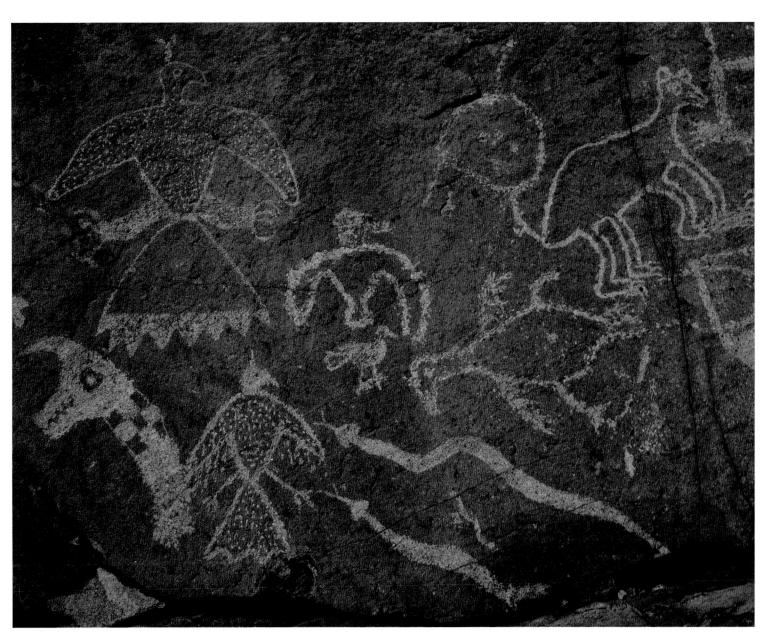

Left: *In northcentral New Mexico, a volcanic dike extends for miles and passes near a large Tano or Southern Tewa Pueblo. A dancing male figure grasping a corn plant may speak across the ages of men in Pueblo culture planting corn and germinating the earth.*

Above: *Eagles, snakes, and a horned serpent are some of the Rio Grande Style carvings on this basaltic dike. Plumed serpents figure prominently in the Pueblo peoples' religion. Connections are drawn to the great Toltec civilization's Quetzacoatl, the god of learning.*

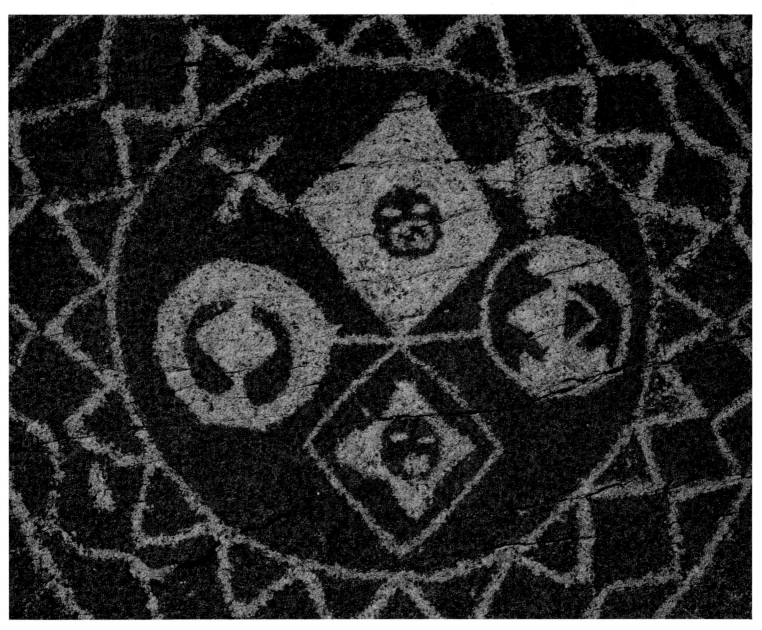

Warfare is a prevalent theme inscribed near the abandoned Tano or Southern Tewa Pueblo of Galisteo. Many shield-bearing figures were likely carved on the hard basalt between A.D. 1325 and A.D. 1680. Individual shields are richly decorated in symbolism.

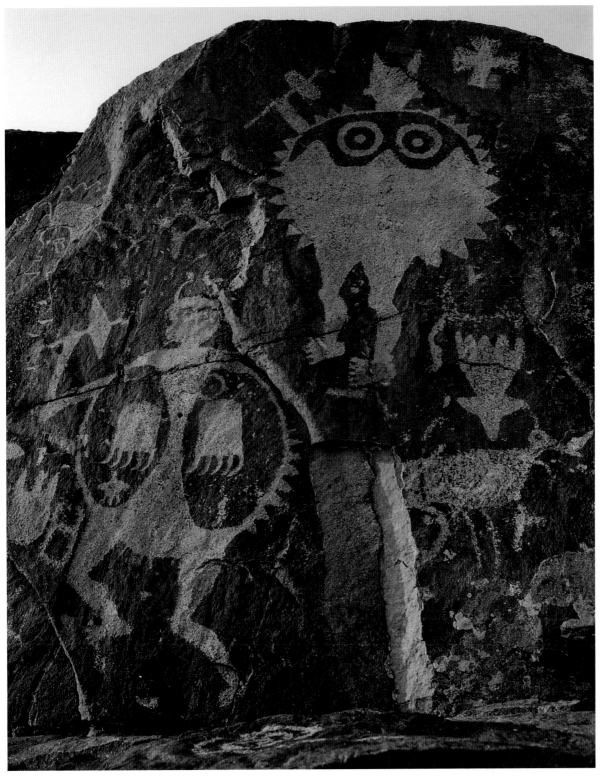

Two shielded warriors brandish menacing tomahawks. Just beyond the pictured scene, a departing enemy, perhaps a Kiowa, has a tomahawk embedded in his hindquarters. Raiding by non-Pueblo people may have caused abandonment of four Southern Tewa pueblos in the early sixteenth century.

Right: *A Rio Grande Style petroglyph of a naturalistic rattlesnake climbs a sandstone wall in the Abo Pass region of New Mexico. Near abandoned Tompiro or Mountain Piro Pueblos exists a rich heritage of rock art dating from the fourteenth and fifteenth centuries.*

Far right: *A Southern Tiwa carving of a masked head wraps around a basalt boulder in Petroglyph National Monument. Congress established the monument west of Albuquerque, New Mexico, in 1990 to preserve an estimated fifteen thousand Pueblo IV petroglyphs carved along seventeen-mile-long West Mesa.*

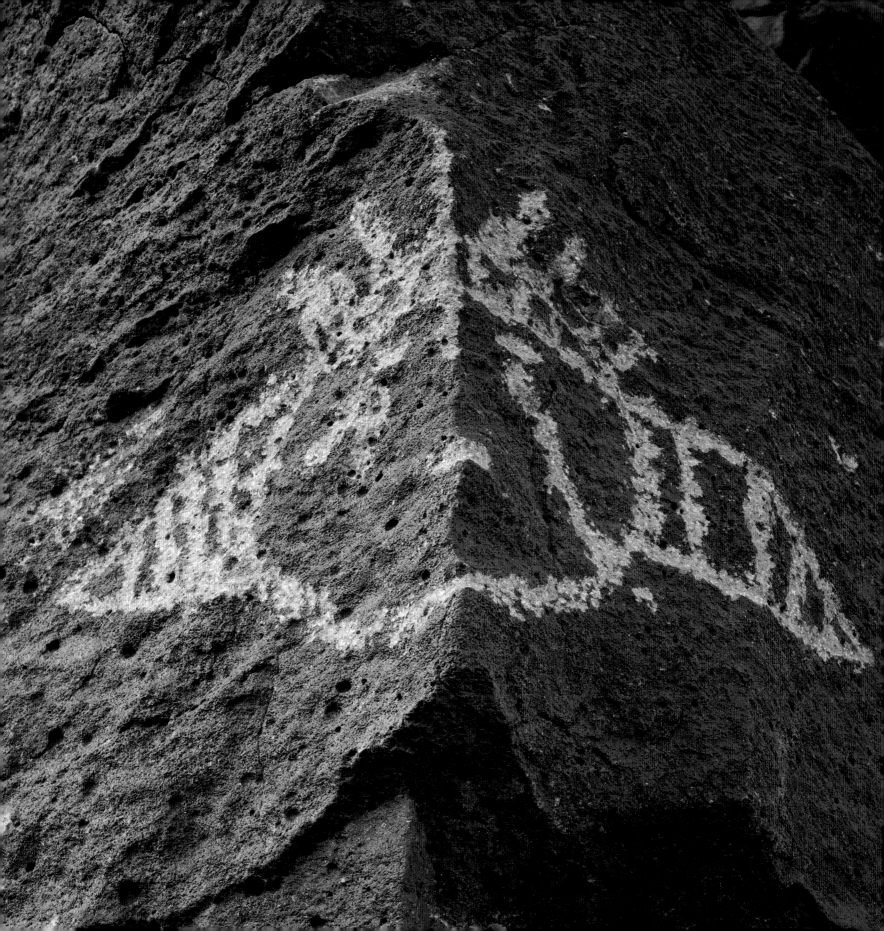

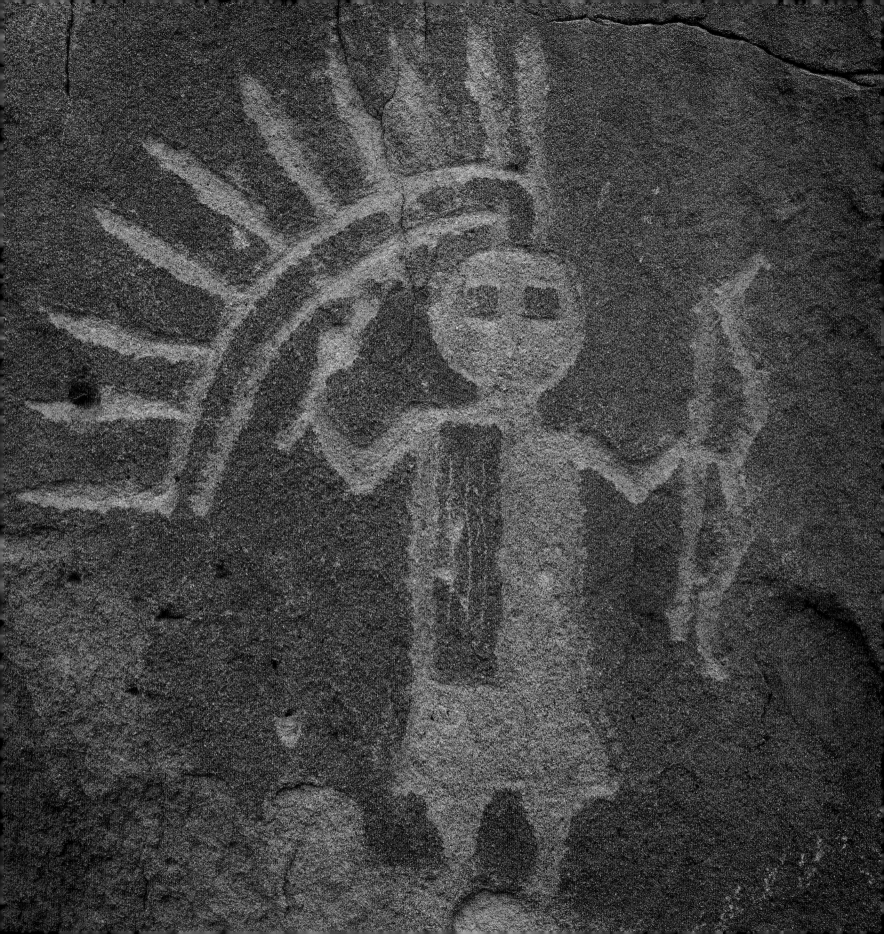

THREE CORN

Ruins of a Navajo stronghold rise from a butte detached from the rim of Gobernador Canyon. Cliffs encircle a fortified compound, isolated on a rock island several hundred feet above the canyon floor.

Along the eastern skyline rises Gobernador Knob, birthplace of Changing Woman, the central figure in the Blessingway chant. This mythic landscape, sung about in many Navajo ceremonies, now sits in the middle of a large gas and oil field.

Climbing a hand and toe route, I enter Three Corn Ruin. The site's name comes from three corn plants pecked into the rock face below it. One petroglyph has almost weathered away. The corn plants appear to stand for those who departed long ago from the heart of the *Dinetah*, the Navajo holy lands. Like other holy lands, this one has its share of fortifications.

Anthropologist John Farella circles the perimeter of the site, looking. For what he isn't sure, pieces of a puzzle mixed with pieces of other puzzles. He returns to the inner ruins. "It's different," he says. "It's just different."

Historic Navajo are generally thought of as nomadic herders using little pottery, living in log hogans, and raiding their peaceful Pueblo neighbors. But for more than a generation after the Spanish reconquest of New Mexico in the 1690s, many lived in pueblitos, small villages defended by a network of stone walls and towers. And they lived alongside Pueblo Indian refugees who had fled from Spanish rule. Together they sought protection from the New Mexican militia and Ute raiders.

Few clues remain at Three Corn to mark their passing. Pueblo-style potsherds lie scattered about, a Spanish-style fireplace stands in a corner, and masonry walls enclose fallen timbers from a forked-stick hogan. Stone axes were still being used in nearby sites, but here collapsed roofs have exposed beams hewn with metal axes, a sign of a changing world.

In a small room, I look up at the roof. Brush fills spaces between beams, sealed above by a layer of adobe. Serviceberry leaves still cling to the roof fill. These dried leaves, a couple of hundred years old, have lasted longer than the memory of those who placed them here.

I follow a narrow passage among the crumbling walls of the eighteenth-century refuge. The huddled architecture reflects the fear that drove the Navajo people here. In the end, their defensive sites may have been as much trap as sanctuary.

Leaving the ruins, we descend into an arm of Cañon Largo. Petroglyphs, many resembling Navajo sand paintings, line the south-facing wall. They possess a quality unlike older glyphs. One panel shows Twin War Gods, sons of Changing Woman. Another shows a man on a buffalo. Some pecked animal figures have a spirit line running from mouth to heart. Archeologists have found Navajo petroglyphs with dried mud still filling indentations for the eyes. Impressions in the mud suggest that stones, perhaps turquoise, were once pressed into them.

Carved into another cliff is *Ghann'ask'idii*, the Humpbacked God, with feathers and horns. It resembles sand paintings still used in the Nightway chant, a healing ceremony for restoring a sense of harmony and beauty. A Navajo singer conducts this cure using sand paintings, songs, and prayers. Archeologists have studied a bundle of ritual paraphernalia, once used in the Nightway ceremony, cached in the canyon long ago.

The purpose of this concentration of rock glyphs is unclear. It may have served as a shrine, a record of clan migrations, or an archive of ritual knowledge. A Navajo once stated they carved ceremonial designs on the cliffs in case the medicine men who knew them died before passing on their knowledge.

Farella tells me the Navajo stopped depicting *Ye'ii*, the Holy People, in permanent medium around 1750 in the Dinetah and

Left: *In New Mexico's Navajo Dinetah, a carving may depict Monster Slayer.*

Above: *Navajos cultivated corn while living in proximity to Pueblo people.*

within a few decades elsewhere. The sand paintings that were created were purposely destroyed as part of the curing ceremony. The Navajo no longer painted and carved sacred figures on the cliffs. During the same period, they stopped making Pueblo-style pottery and abandoned their Pueblo-style dwellings. For reasons still unknown, the Navajo purged these alien ways and moved away from their homeland.

Early next morning I sit by a campfire watching the sky grow lighter. The first sunlight over the rim strikes a large block of rock perched on a ledge across the canyon. Noticing what appears to be irregular weathering on top of the formation, I take out the binoculars. Manmade walls, almost undetectable, stand flush with the cliff face, blending with the sandstone.

I cross the canyon and climb to the ledge. A log leaning against the rock gives access to the ruin. The lookout rock gives a commanding view of the lower canyon. Loopholes set in the walls guard all approaches. Old firewood, cut with a metal ax, lies stacked below, perhaps ready for a signal fire. But before the last fire could be lit, the Navajo left the Dinetah. Some traveled south and west, settling in Canyon de Chelly.

Dezwit Yazzie pulls out of the wash and cuts the engine of the deuce-and-a-half truck. The Navajo guide is transporting a cargo of passengers through Canyon de Chelly in a heavy-sprung, six-wheeled truck. Wearing a cowboy hat and polo shirt, both black, he climbs back to talk.

"We run out of gas," he announces with a straight face. "Everybody has to walk." Nervous laughs come from those wondering if he is serious. Dezwit was born here in Canyon de Chelly. He says the locals call it "Canyon de Chevy" since so many trucks have been lost in the quicksand. He also cautions us against believing everything he says. "When I get tired of telling the same story," he says, "I start telling lies."

A Navajo stone hogan and Standing Cow pictograph in Canyon del Muerto.

An osprey circles high overhead between the walls of the gorge. Creek waters riffle across the canyon floor. In Canyon de Chelly the National Park Service protects one of the largest concentrations of Anasazi cliff dwellings and rock art. *Anasazi* is a Navajo word for the ancestors of the modern Pueblo Indians. To a Navajo, *Anasazi* can mean "ancient ones," "ancient ancestors," or "enemy ancestors." Referring to the thirteenth-century abandonment of the canyon, Yazzie translates *Anasazi* as "the ones that drifted on."

The guide shows us a petroglyph panel of two horsemen chasing a fleeing deer. Although stylized, the scene is animated. Yazzie says a Navajo would ride down a deer until it dropped. The hunter then suffocated the animal with sacred corn pollen so he could use the unpierced buckskin for ceremonial masks.

At a break in the cliff walls, we turn into Canyon del Muerto, a major prong of the main canyon. A few stops later, Yazzie pulls off the dirt road at Standing Cow Ruin. A pickup truck passes with a half dozen Navajo kids riding on the tailgate, roped in to keep from getting bounced out. Navajo families return to the canyon during the growing season to tend their fields. Standing Cow takes its name from the nearly life-size image of a cow painted on the wall. Another Navajo panel depicts a Spanish expedition led by Antonio Narbona that entered the canyon in the winter of 1805.

The Narbona panel shows horsemen, wrapped in cloaks against the cold, riding slowly past with muskets in hand. As these soldiers swept the canyon, they discovered a group of Navajo women, children, and old men hiding in a high cave. Unable to escape, more than one hundred of them died of gunfire poured into their refuge from the rim above.

We return to the main canyon, passing First Ruin, a cliff-house on a ledge. "This is the first ruin these archeologists ruined—I mean worked on," Yazzie says. Smiling, he steers the truck toward the canyon mouth, his work day almost finished.

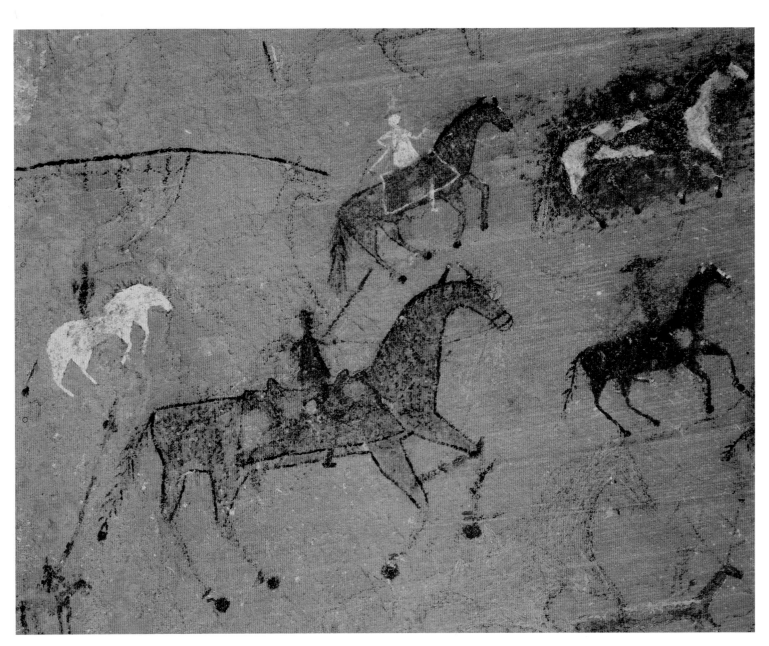

Nineteenth-century Navajo pictographs of horses and riders present a bold sense of realism. Except for four years of U.S. Army-forced exile, Navajos have lived in Canyon de Chelly from A.D. 1750 through the present.

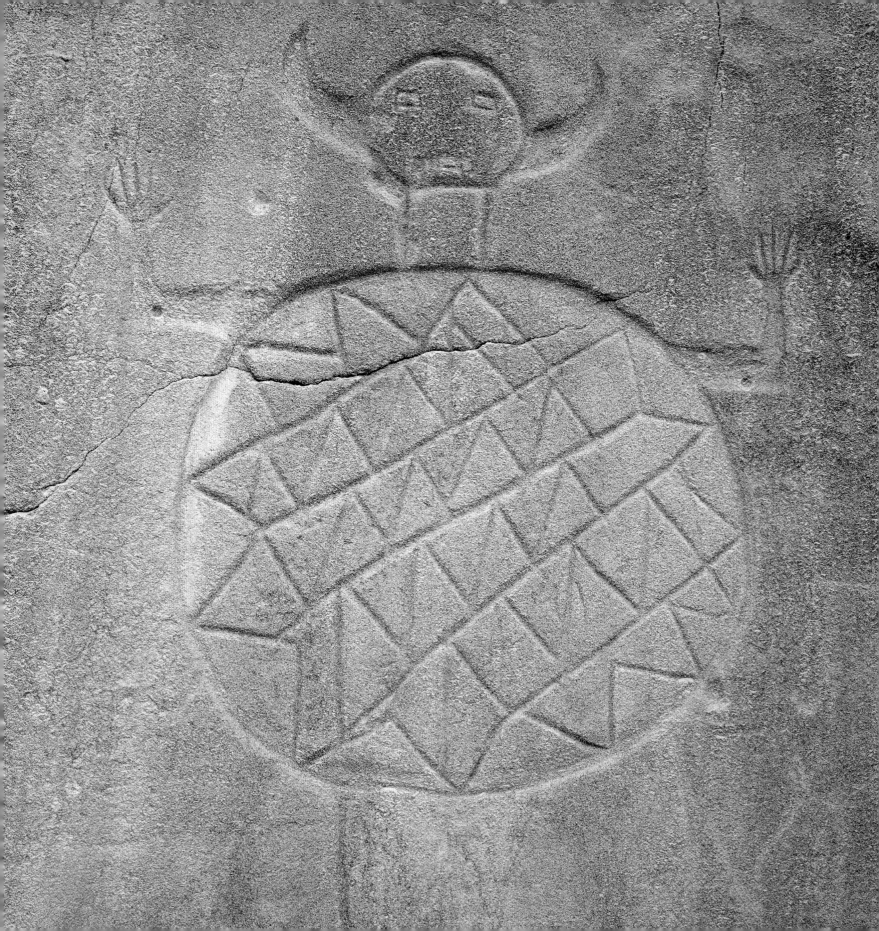

Left: *Small bands of Navajos may have arrived in the Dinetah as early as the fifteenth century. A petroglyph of a horned shield bearer was likely made before A.D. 1750 when the Navajos ceased depicting holy people in permanent medium.*

Above: *More than ninety stars are represented by crosses at a Canyon de Chelly Navajo planetarium. The constellation Anglos know as Scorpio may be depicted in this panel. Some Navajos believe that painted star ceilings help protect against falling rock.*

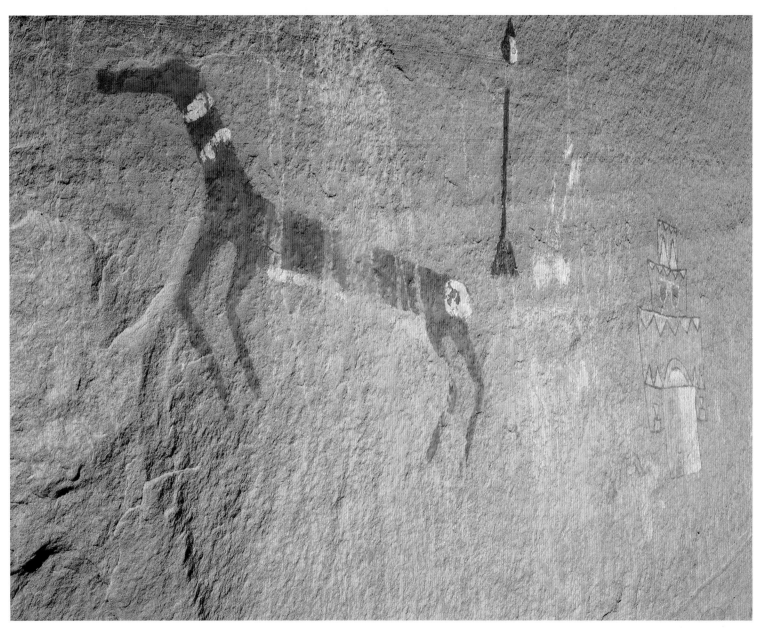

Above: *Navajo renderings of pronghorn antelope and ceremonial Ye'ii share a cliff with a Hopi Style yellow and white stepped cloud design. After the Anasazi abandoned Canyon de Chelly, small groups of Hopi farmers sporadically occupied the canyons from A.D. 1300 to A.D. 1700.*

Right: *Rock art tradition is kept alive by members of the Zuni Pueblo. The cliffs near a prehistoric village are painted with masks from the Shalako Ceremony and Mixed Kachina Dance. Paintings have been added and updated over the past fifty years.*

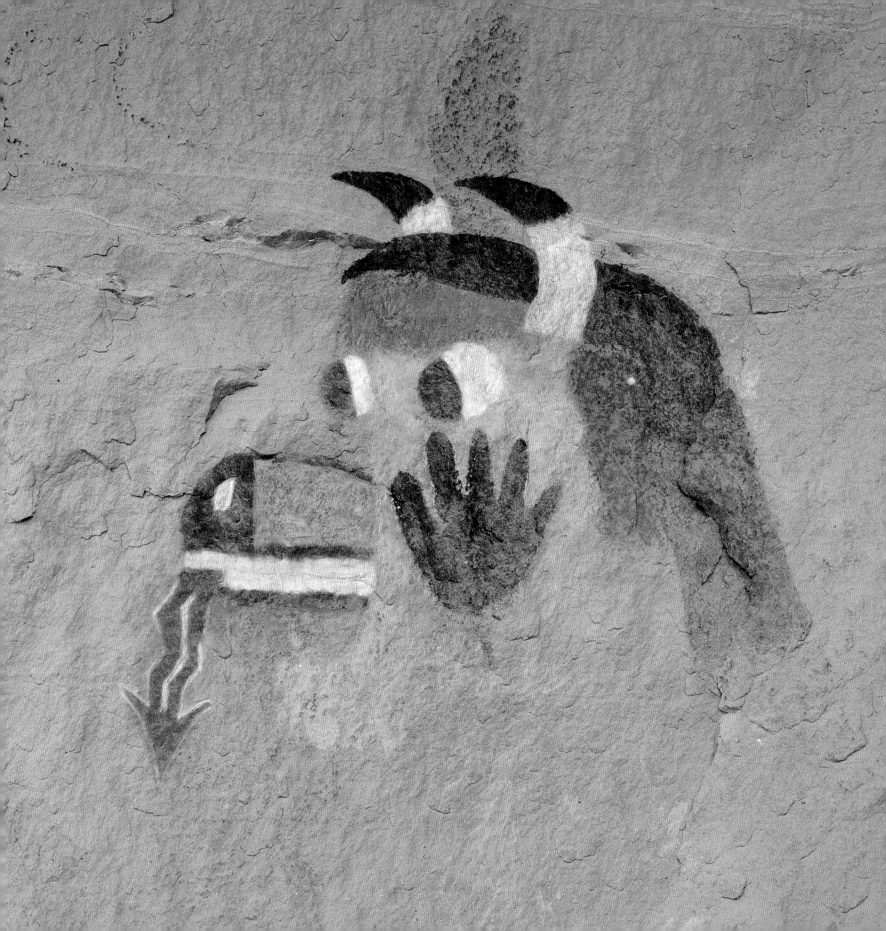

In the deserts of Southern California, certain Kumeyaay people sought out cracks in granite boulders and cliffs. They then enhanced the natural cracking pattern into vulva symbols. Anza-Borrego Desert State Park has a number of these fertility shrines known as "yoni rocks."

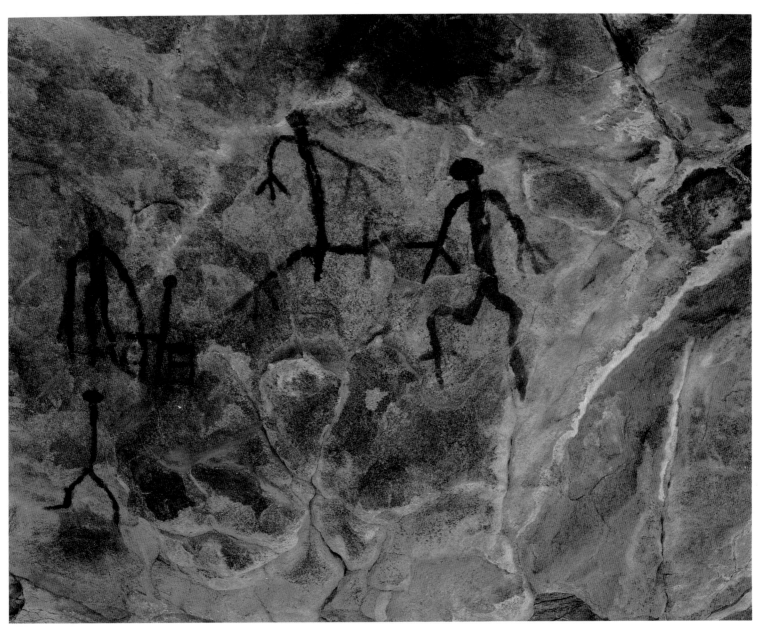

Kumeyaay pictographs of the La Rumorosa Style are preserved on a granite overhang in the backcountry of Anza-Borrego. Painted between A.D. 1500 and this century, it is theorized that the figures may have been made by young boys during the Toloachi initiation.

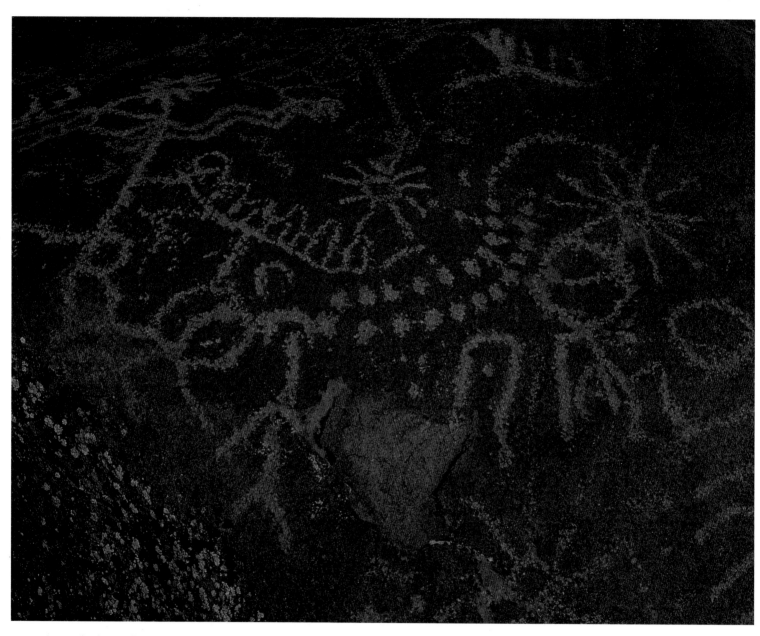

Across the desert of Nevada and eastern California, scores of petroglyph sites contain circular and meandering designs collectively known as the Great Basin Curvilinear Abstract Style. This panel in Mineral County, Nevada, is located next to a major game trail.

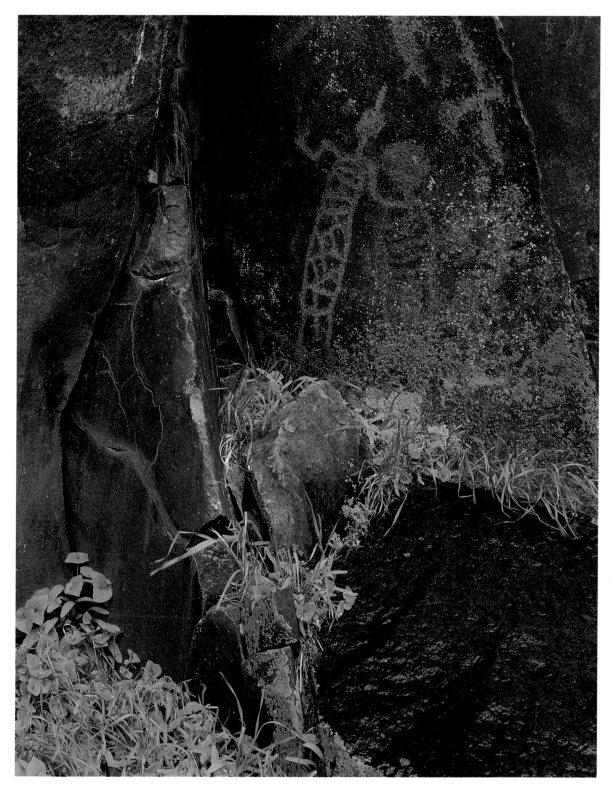

The exquisite rock art in the Coso Range of southern California is thoroughly protected. With the creation of China Lake Naval Weapons Station in 1943, thousands of petroglyphs were closed to public visitation. Some of America's oldest rock art, possibly dating back six thousand years, is sequestered on Department of Defense lands. The Maturango Museum in Ridgecrest offers a limited number of guided trips to Renegade Canyon.

The trademark of Coso Range Style petroglyphs is the bighorn sheep. In just two canyon drainages, more than seven thousand drawings of sheep have been counted. Narrow canyons provided natural funnels through which dogs and people could drive sheep. Hunters waited at ambush sites screened with boulders and above the canyon floor.

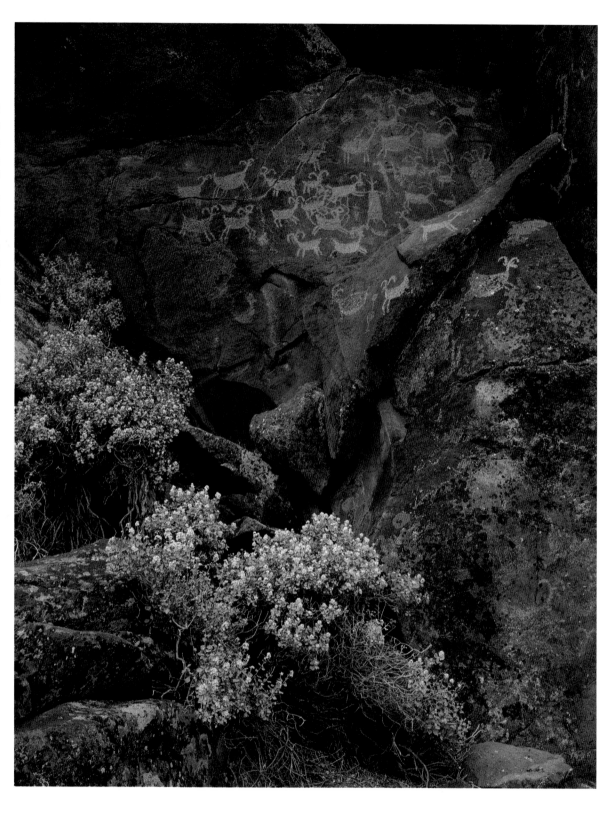

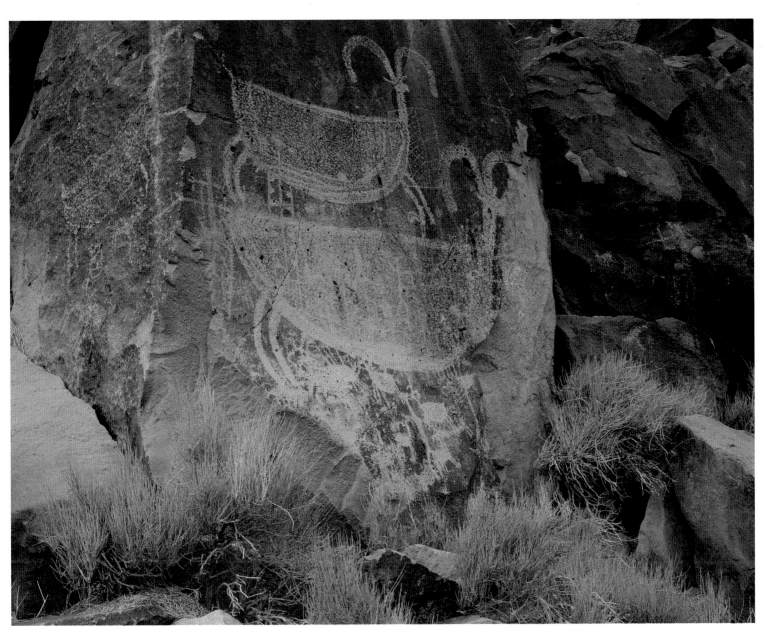

The largest sheep petroglyph in the Coso Range measures about seven feet long. Superimposition over earlier drawings is commonplace and seems to be done with intent. Perhaps a sheep pecked over a human form impowered the human with better hunting abilities.

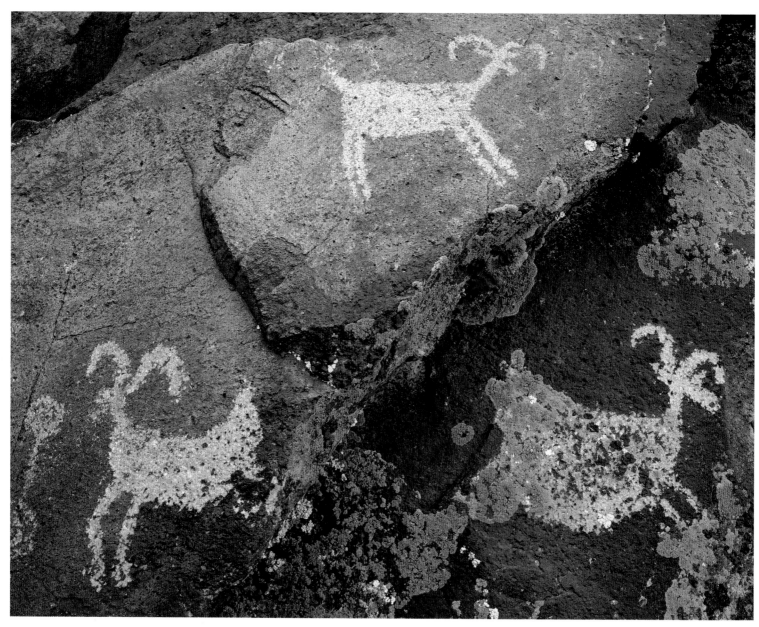

Coso Range sheep are often shown with horns curling apart. Most other southwestern cultures drew sheep with a pair of horns curling back. Sheep of China Lake usually exhibit considerable animation and are most often drawn in a running pose.

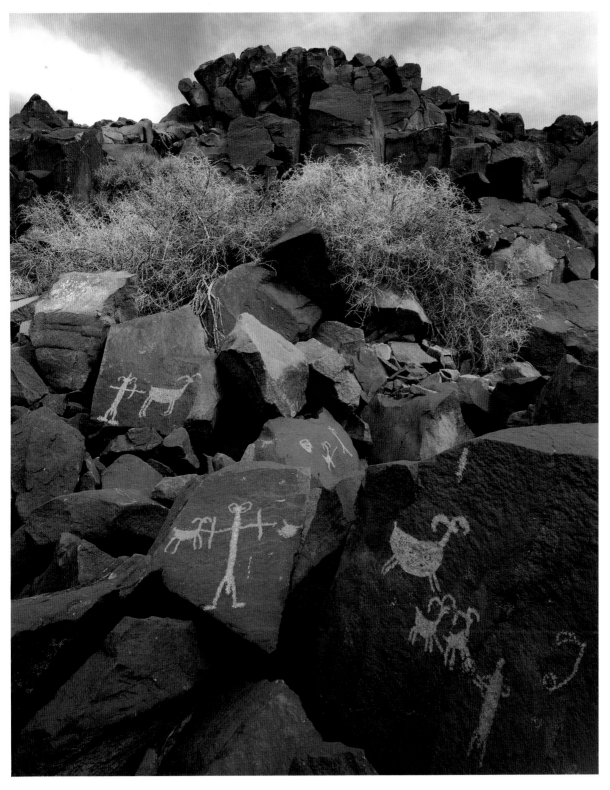

The transition between atlatls and bows likely took place with the Numic Soshoshonean people of the Coso Range between 200 B.C. and A.D. 300. Bows and arrows were a more efficient means of hunting and may have eventually led to the demise of sheep populations.

Virtually in the shadow of the Eastern Sierra, a Great Basin Curvilinear Abstract group of carvings spreads along twenty-one feet of a boulder's surface. North of the Coso Range, none of the stylized sheep appear in rock art of the Owens Valley.

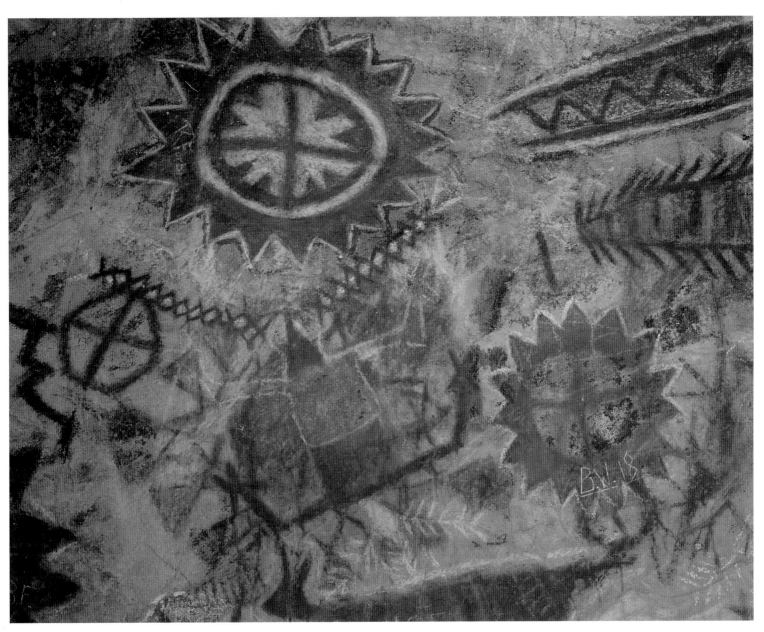

Painted Cave near Santa Barbara, California, contains a bold collection of Chumash polychrome paintings. An elaborate array of spoked circles, abstract shapes, and zoomorphic creatures adorn the walls. The pigments were applied with a binder of animal or vegetable oil.

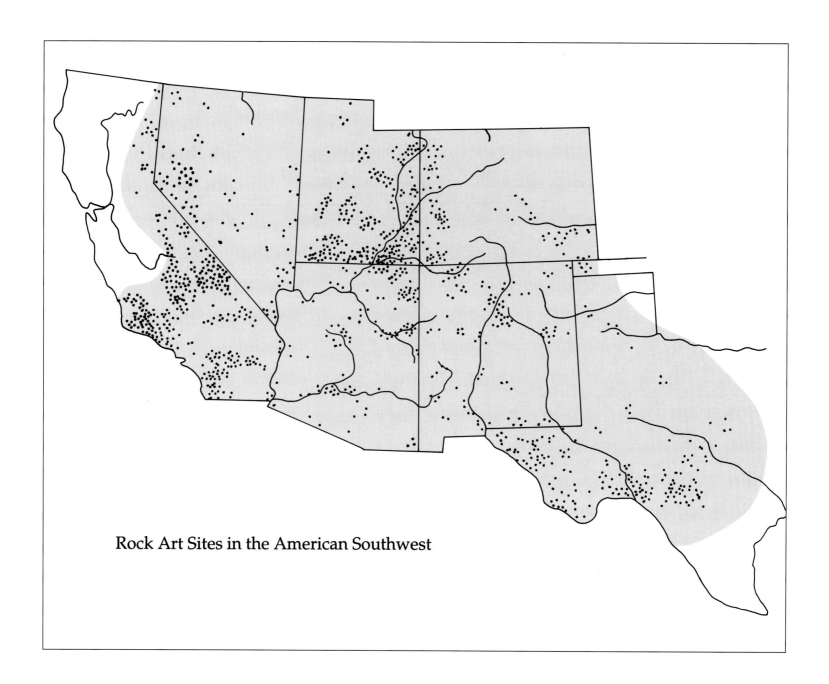

Rock Art Sites in the American Southwest

CAVE ONE

A Navajo sheep herder trails his herd below the cliffs of Skeleton Mesa. Rifle strapped to his back, he heads toward a creek, counter-sunk in an eroded channel below the road.

Turning off the paved road, I park the truck as Brown Russell and Roger Henderson climb out the passenger side. Henderson lives in a hogan he built on the edge of Flagstaff. Russell has recently returned to the Southwest after practicing law and teaching political philosophy.

We head toward a half-dome of Navajo sandstone, sheltering petroglyphs left by the Anasazi. We follow the curve of the wall where pecked figures cover smoother faces—a bearpaw with claws, a human with bird feet, a lizard man. Often prehistoric glyphs are intended as more than one thing, a visual pun.

Flute players and horned animals stand grouped together on one panel. The pattern repeats itself on the next wall but with slight variations, repetition without monotony like the cycle of day and night. I once listened to a medicine man tell a story, repeating each segment several times. He circled back on his tale, shading each retelling with a different emphasis and tone of voice to weave in a richer texture of meaning.

Working along the rincon, we pass between the cliff face and a block of fallen rock. It stands before a portion of the wall carved with a few simple designs—a row of dots, a spiral, and a long snakelike zigzag. The boulder casts a wavy shadow line on the cliff, matching the sinuous pattern of the petroglyph. As the day lengthens, the shadow swings toward the carved zigzag, one snake overtaking the other.

On the walls of the canyon a thousand years ago, Anasazi Indians observed the interplay of light and shadow and incorporated it into their design. The motion of the sun added anticipation and resolution to the otherwise static images they carved, creating a narrative composed of stone and sky.

Farther along the rock face, an atlatl dangles from the hand of a stick man as his spear pierces the chest of a bighorn sheep.

The moment of death. Startled, the water birds carved nearby take flight.

Suddenly, a gunshot explodes down the canyon, catching us off guard. We stop, listening to the after-pulse, waiting for the next shot. Nothing. The sheep herder has found the coyote.

We return to the truck and drive past the Tsegi Trading Post. Tsegi, a Navajo word meaning "among the rocks," is one of several terms they use for canyon. Roger lived here for a year and a half, working as an archeologist for the tribe.

During the course of his work, he met a woman from the remote community of Navajo Mountain who had undergone a traditional marriage ceremony a few years earlier. Following the old custom, the families of the bride and groom arranged the marriage. The first time the woman saw her husband was the day of the wedding. She entered the hogan where he waited with his family. One look, she told Roger, and she knew it could not work. He appeared to be a nice man, neat and clean. "But," she said, "he wore double-knits—double-knits!"

We go on to a canyon with a number of early Basketmaker sites. Parking the truck, we do not lock up. If someone wants to break in, they will. An early traveler in the Navajo country placed a human jawbone on his pile of gear when he was away from camp. He counted on ghost fear to keep enemies away. Roger says a friend of his leaves a blanket spread across the seat and a waterbird, a peyote church symbol, on the dashboard. "It's cheap insurance," he adds.

As we walk up the creek, the canyon walls screen us from the wider sky. A grove of scrub oak stands on a terrace, the bare limbs fingering upward. Dry tumbleweeds cling to the ground, waiting for the next strong wind to roll them away.

Henderson leads us out of the creek bed toward an arching cavity in the cliff face. Eighty years ago, noted archeologists

Anasazi cross at sunset forty-five days before or after the winter solstice.

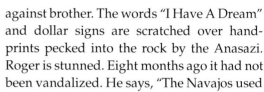

Alfred Kidder and Samuel Guernsey excavated dozens of Anasazi burials from this site, a place they called Cave One.

Digging into a burial cist, they unearthed the body of a teenage mother and a baby. Beneath her lay a scalp with the face attached, extraordinarily well preserved in the dry cave. The hair had been carefully dressed in side-bobs and a hair knot sat wrapped in string at the nape of the neck. The face was painted with a green stripe and bands of red and white. A loop on top suggested the strange artifact had been tied around the woman's neck. The archeologists called it a prehistoric "trophy."

High on a sandstone face, beyond the San Juan River, the Green Mask looks down upon ruins and burial cists. The unusual pictograph resembles the facial scalp from Cave One. Petroglyphs along the San Juan also show similarities to it, leading some to suggest a scalp cult among the early Anasazi.

Pressed under a mass of overbearing rock, the mouth of Cave One opens dark and hollow above us. The place feels wrong. Most Anasazi cliff sites face sunward; this burial cave opens to the north. The air grows noticeably colder as we pass beneath the lip of the overhang and scramble up the steep slope. Breakdown chokes the dry interior, and fragments of human bone litter the floor. Studying the ground as I walk, I don't see the destruction until Henderson gives a shout.

Above us crude scrawlings fill every boulder, every wall. Drawings in black charcoal deface the cave with garbled images of sex and death and cult rock and roll. A frenzy of vandalism has covered the cave with coffins and crosses, an electric guitar and a naked woman, a dark bird rising from a heart and the words "See the Light" and "Blood Feast."

Graffiti runs across Navajo pictographs of two archers facing off with drawn bows, a mirror image of each other, brother against brother. The words "I Have A Dream" and dollar signs are scratched over handprints pecked into the rock by the Anasazi. Roger is stunned. Eight months ago it had not been vandalized. He says, "The Navajos used to believe that when people die, evil remains. They became ghosts, *chindi*, like the *Night of the Living Dead*. This place was left alone from the 1830s when the Navajos came here until this summer—this summer. And then something happened."

Traditional values slip away and with them the old fears. These modern pictographs no longer reflect the vision of a people, but a young Navajo's nightmare of a world gone wrong.

We do not spend long in Cave One. I feel uneasy here. On the way out I find a final message, whether a history lesson or the name of a heavy metal band I am not sure. It says simply, "Manifest Destiny." Our myths have come back to haunt us.

Reaching the canyon floor, we cross to the far cliff washed in sunlight. Someone has carved the Chicago Bulls logo, an angry bull head, next to a fine prehistoric bighorn, four-feet long. Nearby lies the name Everett Ruess cut beneath the puzzling date of 1954, twenty years after the young artist disappeared in the canyon country farther north. Turning toward the mouth of the canyon, we don't linger. Brown feels someone is following us. "That cave," Roger says, "always gives me the creeps."

Before leaving, we climb to the ruins of an Anasazi pueblo. Slickrock, creased into a tangle of rills, sweeps up behind the standing walls. Finely laid, they have lasted for centuries. The outer face of the masonry has been rubbed smooth and a few stones incised with geometric designs.

Historic inscriptions also mark the ruins. Novelist Zane Grey found a stone to carve his name. The earliest names date to 1859 when a company of mounted rifles passed by on a reconnaissance of Navajo country. Manifest Destiny.

Inside the doorway someone has left a message. It says, "Do you really believe all what they say about this place?"

Multiple cans of spray paint gone wild on the Navajo Reservation of Arizona.

INDEX

Petroglyph of ornate Anasazi blanket design along the Little Colorado River.

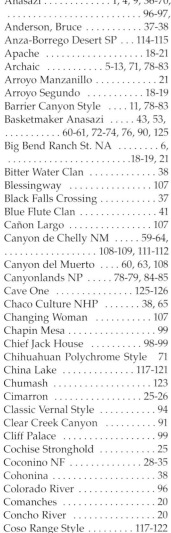

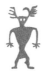